KT-168-977

Photography: A Very Short Introduction

Very Short Introductions available now:

Steve Edwards

PHOTOGRAPHY

A Very Short Introduction

OXFORD
UNIVERSITY PRESS

OXFORD

UNIVERSITY PRESS

Great Clarendon Street, Oxford OX2 6DP

Oxford University Press is a department of the University of Oxford.
It furthers the University's objective of excellence in research, scholarship,
and education by publishing worldwide in

Oxford New York

Auckland Cape Town Dar es Salaam Hong Kong Karachi
Kuala Lumpur Madrid Melbourne Mexico City Nairobi
New Delhi Shanghai Taipei Toronto

With offices in

Argentina Austria Brazil Chile Czech Republic France Greece
Guatemala Hungary Italy Japan Poland Portugal Singapore
South Korea Switzerland Thailand Turkey Ukraine Vietnam

Oxford is a registered trade mark of Oxford University Press
in the UK and in certain other countries

Published in the United States
by Oxford University Press Inc., New York

© Steve Edwards 2006

The moral rights of the author have been asserted
Database right Oxford University Press (maker)

First published as a Very Short Introduction 2006

All rights reserved. No part of this publication may be reproduced,
stored in a retrieval system, or transmitted, in any form or by any means,
without the prior permission in writing of Oxford University Press,
or as expressly permitted by law, or under terms agreed with the appropriate
reprographics rights organizations. Enquiries concerning reproduction
outside the scope of the above should be sent to the Rights Department,
Oxford University Press, at the address above

You must not circulate this book in any other binding or cover
and you must impose this same condition on any acquirer

British Library Cataloguing in Publication Data

Data available

Library of Congress Cataloging in Publication Data

Data available

Typeset by RefineCatch Ltd, Bungay, Suffolk
Printed in Great Britain by
Ashford Colour Press Ltd., Gosport, Hants

ISBN 978-0-19-280164-7

For J X B, J W (and G)

Contents

Preface

I must have been mad to agree to write this book; not least, because the combination 'very short introduction' with 'photography' seems like a paradox. The three or four standard histories of the medium are all huge volumes. The problem is simply that photography runs in all directions, permeating diverse aspects of society. Indeed, it is difficult to find an area of modern life untouched by it. (Even the cover of this book, ostensibly an abstract painting, is photomechanically reproduced.) The critic John Tagg once suggested that there was no single characteristic, or practice, that represented the fundamental essence of the medium. Trying to account for photography as a whole, he suggested, was akin to attempting a history, or a museum, of writing: all that could be done was to trace the uses of photography (or writing) in the institutions in which it was put to work – the law courts, medicine, advertising, art, and so forth. Even if we reject a strict version of this argument (it seems to me that there are powerful ideologies underpinning the uses of photography), attempting to write an introduction to this dispersed field feels like a vain task. The quite distinct versions of photography's history unravel attempts to tell a coherent story. This is one of the things that can make thinking about photography so fascinating, and so challenging.

In this short book I have not even tried to provide anything like a

comprehensive account: some of the most important aspects of the field – advertising, for instance – barely figure here. Instead, I have tried to address some constitutive conditions that give rise to the values we typically associate with photographs. This approach means emphasizing the division between art and documentary. I have also adopted a thematic, rather than chronological, organization for this book; information on the development of photography, for instance, is scattered throughout the pages. My aim has been to embed specific information in a wider frame – I hope this approach results in a livelier introduction to the subject, but the reader may need to actively look for connections. Chapter 1 takes the theme of forgetting as a way of introducing photography. Chapters 2 and 3 form a complementary pair, providing a survey of issues and themes associated with the division between 'documents' and 'pictures'. Chapters 4 and 5 go over some of the same ground, but with a more theoretical emphasis. The final chapter returns to the uses of photography, advancing some thoughts on commodity culture and memory. I felt that I could not leave the book without a short coda on the 'digital image' and its impact on established photographic culture.

Outside the museum, we rarely encounter photographs in a pure, or self-contained, form. Invariably, photographic images are combined with language and some other technology. Photographs often appear on the page (of a book, magazine, or newspaper), combined with text; they figure on billboards (again with words); in archives and filing cabinets; on personal identification documents; in family albums (or, their modern replacement, the reassigned shoe box); on computer systems; and so forth. Photography is a hybrid medium, and it is worth remembering that the way we encounter and use photographic images frequently involves some other system of communication and organization. I touch on this combinatory relation in what follows, but in the main, this book focuses on camera-generated photochemical images, though I have occasionally drawn my examples from the related family of technologies that share the determining conditions of the camera

(film, television, video, and digital photography). One final point: anyone hoping to find a 'how to' manual here will be disappointed.

List of illustrations

The publisher and the author apologize for any errors or omissions in the above list. If contacted they will be pleased to rectify these at the earliest opportunity.

Chapter 1
Forgetting photography

The question 'Where is the photograph?' presupposes that we have
lost sight of photography or that photography is somehow lost; that
it has lost a direction perhaps or that we do not find it where it
should be; that it has been misplaced; that it remains somewhere,
unclaimed, in some lost property office of culture.

Olivier Richon

In 1865, the photographer James Mudd presented a paper entitled
'A Photographer's Dream' at the Manchester Literary and
Philosophical Society (Photographic Section). Mudd tells the story
of a photographer who falls asleep and wakes in the 29th century.
This fable represents a parody of, what Mudd saw as, the dire state
of photography in the mid-19th century. His goal was to see
photography valued as one of the fine arts (his particular passion
was for picturesque landscapes), but photographers obsessed with
chemical processes and optical devices undermined this ambition.
In his 'dream' he was conducted through a swanky new Manchester
to the 'Grand Focus Photographic Society'. But, whereas he had
expected to find photography transformed into art, he encountered
just more of the same. The participants in the Society came up with
one mad scheme after another: a camera, called a pointer, wound
up and sent in search of views; steam proposed to raise
photography to new heights; and so on. Mudd was aghast to find
that photography had not really changed in all this time; still no one

seemed interested in art. In fact, it turned out that there had been little opportunity for progress; he learned that, in the intervening years, photography had been lost and had only recently been 'discovered'. This simple tale proposes a period of more than 1,000 years of modern history without photographs. It is a remarkably interesting idea.

William Bornefeld's science-fiction novel *Time and Light* is set in a post-apocalyptic society called Fullerton, where photographs are forbidden. In place of the seductions of images, the inhabitants of Fullerton have the 'pill' (half anti-depressant, half sexual stimulant). But, during a scientific expedition to the (allegedly) irradiated world beyond the domed city, the central character, Dr Noreen, discovers 12 ancient photographs from the 20th century. Even during his medical training Dr Noreen's contact with pictures had been restricted to a few diagrams. But when he encounters an ancient archival facility and takes a packet of images (oddly enough, all by well-known photographers; including one by the author) he becomes obsessed with these illicit pictures and flouts the iconophobic rule that predominates among the last surviving humans – which Bornefeld calls, in a bad photographic joke, 'The Family of Man' – spending hours absorbed in contemplating an image of peppers by Edward Weston, or Robert Capa's picture of a Spanish Republican soldier depicted at the moment of his death. Noreen is rash enough to show his images to two other citizens: gradually his promising career and social progress disintegrate around him. Ultimately, Noreen's search for more photographs leads him to challenge the norms and protocols that govern Fullerton: the ruling bureaucrats respond with the ultimate iconophobic gesture and surgically destroy his vision.

It is difficult for us to imagine these imageless future times. The rapid spread of phone technology for making photographs has only exacerbated this situation: we all now live our lives in the presence of pictures. Dr Noreen's world, in which photographs are prohibited, seems particularly odd because they do so much work in

our society that it is hard to imagine the ruling powers voluntarily renouncing them. However, it seems helpful to begin this short introduction with Mudd and Bornefeld, and to contemplate a world without photographs. So let's leap forward into the imageless future.

In Mudd's future, if not Bornefeld's, drawings could substitute for camera-generated images, but drawing is a slow, and highly skilled, process. One key impetus behind the invention of photography in the 1830s was the desire to escape from the restrictions imposed by handcrafted images. What is more, in the absence of photographic reproduction techniques, if drawings are to be issued in significant numbers they will need to be hand engraved onto a metal plate or wooden block. Two key consequences result from this laborious technique: both would significantly limit the number of images in circulation.

Firstly, hand-drawn images are expensive to produce, because they require skill and time. When picture production involves the expenditure of effort, time, and money, images are likely to be restricted to the illustration of significant things. Photography, in contrast, excels at depicting everyday life and casual appearances. Consequently, throughout its history, the hand-made image has been, invariably, reserved for prestigious projects: images of the powerful and the famous, world historical events, subjects deemed elevating or worthy of attention by official culture. Imagine, for instance, the magazines currently on display in any newsagent deprived of their photographs. Many of these publications depend for their appeal on their pictures, and a good percentage would, undoubtedly, cease to exist without them. Would gardening, DIY, or fashion magazines, or those weird lads' mags, have half the appeal without their images? Would anyone go to the time and expense of reproducing this stuff in the absence of cameras? The people in Mudd's future would find very few illustrated books, magazines, and newspapers available to them; even for those who could afford them, images of their family and friends would be limited to a few

formal portraits. Secondly, whereas photography is more-or-less instantaneous, even the most rapid sketch requires time to execute. Moving subjects can only be reproduced as an artist's impression. (It took photography to establish the way a running horse plants its feet.)

In a number of pioneering texts written during the 1920s and 1930s, the German critic Walter Benjamin argued that photography should be thought of as a technology of the 'optical unconscious'. Benjamin's analogy was with psychoanalysis, which allegedly brought the murky realms of the unconscious into view: he believed photography did something similar for the aspects of our world that eluded standard vision. He had in mind the ability of the camera to extend human observation beyond its normal parameters. All manner of instruments are regularly employed to enhance vision: eye-glasses, magnifying glasses, simple microscopes, and telescopes to name just a few. Some of these instruments are straightforward to use and we are readily familiar with their results. These optical devices are, though, designed to be used individually and communicating their findings can be difficult. What an observer sees in a simple microscope or telescope can be recorded in a drawing, but doing so requires a great deal of skill and patience: the objects of study often move or metamorphose, and the focus of attention has to be repeatedly shifted from the eyepiece to the paper. (There are plenty of examples in which what the observer recorded did not exist.)

The camera is particularly suited for combination with optical devices because the instrument can be substituted for the regular lens and rapid modern shutters and films allow for an almost instantaneous arrest of motion. In this way, images otherwise invisible to the eye can be revealed. Some complex instruments – scanning microscopes, ultrasound scanners, and so forth – require a photographic image (or video/computer screen) to manifest their results: there is nothing to see in the absence of photographic film or screen. Images from inaccessible places are also made available

by photographers (not many of us are likely to explore the depths of the ocean). Satellite photographs of the Earth and its weather systems, or images of distant planets, are only possible from a point of view that is literally 'out of this world'. The ability to make pictures at a fraction of a second (or in film to slow down motion and freeze frame) brings things that we could otherwise never observe into focus: we are able to discern whether the ball crossed the line or to capture a humming bird in flight. Infrared photography allows us to see in the dark, while telescopic photography enables observers to record dangerous events at a safe distance (or to spy and pry). If we add the microcameras that enable medics to see inside the body without the need for invasive surgery to this list, the stakes are raised once more. Much of our world would be invisible to those in the imageless future cities of Manchester and Fullerton.

It is difficult to grasp just how much would be lost to us under these circumstances. Most of all, I suspect, the inhabitants of the future would miss out on pictures of simple appearances: the look of a volcano erupting, or a close-up of a dragonfly's wings; the pattern made by a drop of water, or the record of a daft outfit worn at a party. The world would seem much less knowable in the absence of these images: our familiarity with tropical islands and deserts, anacondas and aardvarks, stems, in the main, from lens-based imagery. (Perhaps zoological and botanical gardens would undergo a spectacular revival in the photo-less millennia.)

Much of our familiarity with our world comes through photographic visualization as a surrogate for first-hand experience of places, objects, creatures, and events. Photographs have made many things seem ordinary, bringing distant places or unusual things closer to us, but, at the same time, our reliance on them has been at the cost of making much of our experience seem second-hand. It is startling to think how much of our knowledge comes through the medium of photography: how many of us have actually

seen a polar ice flow or a refugee camp? Yet we are able to describe the appearance of both. In this sense, we relate to our world through the 'second nature' of technology. Photography occupies a central role in that process. An iconophobic future might make some important gains by dispensing with the mediation of cameras, but the costs would be immense. Images associated with the optical unconscious have played a fundamental role in demystifying our world; without them enchantment would have a greater grip on our understanding.

As we have already observed, in Mudd's future dependence on drawings would mean the everyday images of friends and relatives, pets and prized possessions, would be likely to disappear: there would be no envelopes stuffed with pictures from high days and holidays. These things are completely absent from Noreen's Fullerton. In these imageless societies, it is likely that many people would leave no visual trace of their lives. This was the condition for most of the world's inhabitants before photography (early photographers often dreamed of a photograph of Shakespeare), and after its loss, or eradication, most people would return to what the critic Siegfried Kracaeur called, in another context, 'imageless oblivion'. However, this situation would, once again, allow the prestige of pictures to devolve to the rich and powerful. (For the poor and the powerless, the ability to avoid the official gaze has some definite advantages.)

The modern state employs photographs (and other related lens-based media) in myriad ways, and, at least, in Bornefeld's full version of 'imageless oblivion' its operations would be considerably hampered by their absence. In addition to political 'spin' and promotion, images of this kind are used for disseminating public information; traffic control; recording forensic evidence and presenting that evidence in court; surveillance in banks, city streets, or on demonstrations; for staking out a criminal suspect and recording his or her contacts. Perhaps, most of all, photographs are employed to produce

records of individuals. All manner of official documents demand portraits of their holders, including passports, driving licences, library cards, and so forth. In many parts of the world people are obliged to carry identity cards (British citizens may soon be required to join them). Imagine how much easier it would be to take on a different identity before – or after – photography. Charles Dickens gave a great description of the trouble it took to identify individuals in a period before their likenesses could be photographically produced. For example, jailers were required to scrutinize each prisoner and memorize his or her appearance. The police began using photography seriously in the 1870s. With the emergence of fingerprinting, and subsequently DNA testing, photography occupies a less central place in identification. But, while these other technologies allow identity to be confirmed, photographs make it much easier to spot an individual. In Noreen's future, the police can keep tabs on everyone because there are so few remaining people; in contrast, Mudd's millennia without photographs must offer lots of possibilities for becoming invisible, for moving city and starting over.

There are some phenomena in our society that are, to a large extent, the products of photography and could not survive in these future worlds, or at least could not do so in their present form. Two examples will have to make the point. Celebrity is one of those phenomena that could hardly exist without the camera. Fame predates photography, but celebrity developed with the image technology of industrial capitalism. In the 1860s British dealers regularly ordered 10,000 photographs of prominent celebrities. The revival of the popularity of the British royal family dates from roughly the moment around the middle of the 19th century when they began to promote themselves as homely bourgeois citizens. Photography played an important role in this process. The first photograph of a member of the British royal family to be shown in public appeared in 1857; within a few days of its issue, in 1860, 60,000 sets of Mayall's photographic *Royal Album* had been ordered. From the point at which image and text

could be produced in mass editions (the late 19th century), a symbiosis took place between popular journalism and celebrity: the publicity-hungry could then keep themselves in the public eye, while the media traded on this visibility. The modern tabloid press feeds on celebrity pictures, even if these days they show considerably less reverence for their subjects. Increasingly, paparazzi work has become more prying and voyeuristic, but this

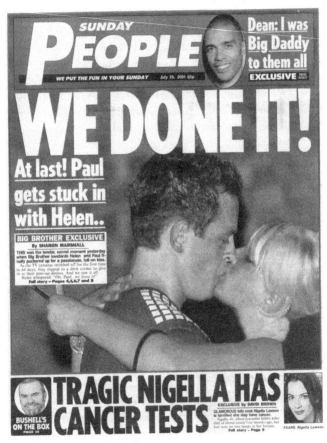

1. The *Sunday People*, 29 July 2001

logic is implicit in the celebrity image. To be famous in Fullerton, you actually have to produce something, or do something, even if only the bad poetry-cum-rock-and-roll of chief poet Kafahvey.

Advertising – unquestionably one of the central roles for photography in capitalist society – presents a different case, since commodities can be hyped with words or drawings. The rise of modern commodity culture, once again, though, seems to have developed in tandem with photographic reproducibility. In part, this is to do with the ability to disseminate images through the mass media. But the characteristic of the photographic image clearly has something to do with the power of advertising: the celebration of commodities seems to thrive on the kind of high-resolution, high-key, glossy image provided by photographs. With no celebrities staring from the tabloids and limited advertising, the imageless future has some things to recommend it!

Noreen trained as a medical doctor with a few diagrams and the experience of the dissecting table, but modern medicine would be severely hampered without its images. Medical training combines dissection with study from photographs (or photographically reproduced illustrations). It can be easier to identify a particular pathological condition from an abstracted image than from the contingent forms it actually takes. Photographs make available an archive of diseases unfamiliar to the individual doctor or nurse. No doubt, in the absence of photographs, memory would find other ruses for recording these things, but picturing them is highly convenient. While the X-ray is not strictly a photographic technology, it becomes visible when recorded on photographic film, and all manner of surgical procedures now depend on introducing microcameras, endoscopes, and the like into the body.

If the restraints on commercial culture and surveillance might seem beneficial effects resulting from the restriction on photography, the consequences of the imageless society for medicine seem altogether less desirable.

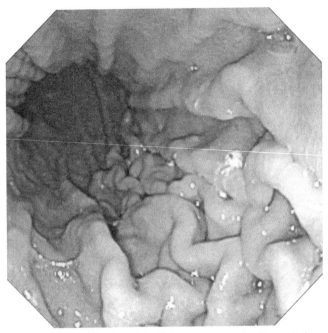

2. **An image of the interior of the body. Gastroscope (endoscope) view of a healthy stomach**

The inhabitants of this future would, no doubt, miss some types of photograph much more than others: some of these pictures seem indispensable, others burdensome. Overall, in their absence the world would seem less busy and probably more alien.

At this point, let's put the time machine into reverse gear and travel back to the mid-19th century: the point at which photography was beginning to colonize the image culture of capitalist society. In 1864, Dr Hugh Diamond – editor of *The Photographic Journal*, and pioneer photographer of mental illness – wrote the report on the International Exhibition of 1862. In this assessment of the state of photography, he claimed there was 'scarce a branch of art, of

science, of economics, or indeed of human interest in its widest application, in which the applications of this art [photography] have not been made useful'. In medical science, he said, it was used in 'morbid anatomy of malformation and disease generally' as well as recording 'the progress of cases and illustration of surgical treatment'. It was employed in ethnological science and natural history where 'no other mode of delineation' could compare with it, and it provided an essential service in 'giving a permanent form to the enlarged images of the microscope'. 'The archaeologist and antiquary, the virtuoso and historian' all used photographs, while for 'the architect and engineer it supersedes and far surpasses in many cases drawings made by hand'. Photography had an important place in law: reproducing documents and 'pursuing the criminal'. For manufacturers, it 'depicted designs, patterns or workmanship'. And lastly, Diamond claimed, 'more ambitious still, as if the globe were too narrow a sphere for its resources, it travels into space, seeking and taking records of the phases of other worlds, and of that great body, the sun'. When he claimed that photography ventured into space, he meant this metaphorically by being attached to the lens of a telescope: now cameras are fixed to space probes and beam back startling images of Saturn's rings. Mid-19th-century photographers and their champions often wrote lists like this in a celebratory vein (in part, we suspect, because their professional status was not that secure), but they were not wrong in observing the rapid spread of their images through society. Since Diamond's day, the uses of photography have only proliferated. As the critic and curator John Szarkowski noted in 1976, there are now more photographs than there are bricks. Each one of them, he said, was unique. Accounting for this number of images and their uses is not an easy task.

Chapter 2
Documents

Documents and pictures

This chapter and the one that follows examine a central division in photography – that between 'documents' and 'pictures', or, to put it another way, between 'documentary' and 'art-photography'. All of these terms are problematic, but the distinction is real and has generated much of the photography we routinely encounter. The photographic document, like other kinds of document, is typically perceived to be a neutral, styleless, and objective record of information. The document is usually thought to be devoid of subjective intention, even of human will – it is frequently claimed that the camera produces images automatically, as if unaided by an operator. For instance, a French caricature from 1840 makes fun of a photographer dozing while his apparatus does all the work. Photographic art, in contrast, lays claim to intention, subjective expression, spiritual uplift, and aesthetic effect. Rather than snooze, photographic artists must be alert.

Some commentators have argued that a serious study of photography should abjure any consideration of art and focus on the instrumental forms and mass practices that are the mainstay of the medium. Photographic art, it is suggested, is an invented tradition, or ideology, and we would do better to look at the tasks photography performs in modern society. This is a strong

argument; not least because the standard histories of photography have, all too often, focused on art at the expense of mass image forms: advertising, legal documents, pornography, anthropological images, topographic views, and so forth. However, there are two good reasons for continuing to study art-photography. Firstly, the early pioneers of photography drew many of their key terms from established conceptions of art: 'photogenic drawing', 'picturesque views', 'prints', and so on.

The language of art was available to photography's first viewers; it shaped what could be imagined and what could be done. The effects

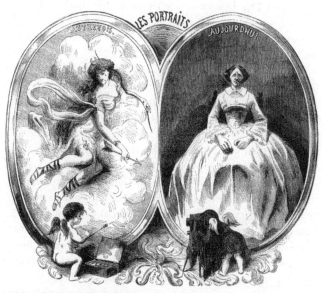

A BAS LA PHOTHOGRAPHIE [1] !!!

TEXTE ET DESSINS PAR MARCELIN.

3. Marcelin, 'Portraits of Yesterday and Today', from *Journal Amusant*, 6 September 1856

of these initial musings have had long-term consequences for our understanding of photographs. Secondly – and this follows on from the previous point – the document and the art-photograph are locked together: these are mutually determining categories that draw a great deal of their meanings from their antithetical relation.

In the history of images, one category of representation has typically been set against the high-flown practices of art and cast in the role of lowly carrier of information. To take just a couple of random examples: during the 16th century, the art of northern Europe was seen as descriptive and realistic, in contrast to the learned painting practised in Italy; in the 18th century, the topographic view (supposedly a literal description of place) was cast against the sublime or picturesque landscape. In recent times, photography (truth or record) has been opposed to painting (emotion or expression). This distinction is reiterated within photography itself: documents are set against pictures. In all of these oppositions, the representational underling is viewed as descriptive and 'matter-of-fact'.

Most of these oppositions have their roots in the distinction between the 'liberal' and the 'mechanical arts', which was enshrined during the Renaissance of the 15th century. Renaissance artists engaged in a protracted struggle to raise the status of their work and with it their social standing. That is to say, painters sought to distinguish themselves from wheelwrights, barrel-makers, and others with whom they were frequently classed. To do this they insisted that their work was a liberal art and not a lowly artisanal (or mechanical) trade. Artisanal labour was viewed by the elite as demeaning. Those who worked with their hands – displaying 'mere' skill, facility, or imitation – were said to be 'servile', because they followed a plan established by others rather than demonstrating their own ingenuity. In contrast to the artisan, the liberal gentleman, who wrote poetry or engaged in geometry, was thought to display learning and intellect and, as such, was said to be

untouched by the stain of work. Artists responded to this argument by attempting to infuse their work with the explicit signs of mental effort: this involved appeals to classical learning, the creation of idealized figures that were not copies of imperfect nature, and characterizing line and drawing as more foundational than mere colouristic effects.

A decisive turning point in artists' protracted struggle over status occurred with the establishment of the Académie Royale de Peinture et de Sculpture in Paris in 1648, and then the Royal Academy in London in 1768. The painter-theorists who directed these institutions – Gerard Lebrun and Sir Joshua Reynolds, respectively – established Academic rules and precedents designed to assert the intellectual content of their work and raise the standing of art. Here is Reynolds:

> The value and rank of every art is in proportion to the mental labour employed in it, or the mental pleasure produced by it. As this principle is observed or neglected, our profession becomes either a liberal art, or a mechanical trade. In the hands of one man it makes the highest pretensions, as it is addressed to the noblest faculties: in those of another it is reduced to a mere matter of ornament; and the painter has but humble province of furnishing our apartments with elegance.

According to Academicians, any art based on copying endangered the practice by proximity to the characteristics associated with the artisan or 'rude mechanic'. In this Academic tradition, the presence of detail, because it suggested copying, had to be avoided at all costs. In contrast, Academic art stressed broad or general effects and idealized forms. Art was characterized by its *distance* from the contingent features of the actual world and in this way signified the presence of an active intelligence. In Reynolds's argument, art and work stand as mutually determining terms: art is noble and elevated, while work is vulgar and base; the artist is a free subject in contrast to the subjected worker.

15

During the 19th century, the Academic tradition was transformed – in Britain by the popularity of genre painting and 'Naturalism', in France by Realism and Impressionism. Nevertheless, many of the structuring oppositions from the Academic tradition remained in place. Copying or imitation continued to be viewed as mindless and mechanical, while invention and idealization were highly valued. Photography took its place within the established cultural antimonies.

In an important essay written in 1857, Lady Elizabeth Eastlake suggested that what photography did best 'was beneath the doing of a real artist'. Photography made exact copies of things: it saved artists' effort, labour, and time, and it freed them to concentrate on imaginative or creative work. Those who wanted to dismiss this new image-form argued that it was just a mindless, automatic means of copying. But art-photographers also repeatedly echoed this distinction, arguing that it was necessary to wrench photography away from the automatic imprint of the apparatus, to imbue it with intellectual characteristics; to reject details, copies, and documents. Within photography itself, then, the same division evident in the Academic tradition was reiterated: documents were seen as objective, mechanical copies characterized by superabundance of detail and practical utility; art-photography aspired to the status of invention and subjectivity. This opposition generated some of the most significant functions of photography.

Objectivity

Photographic documents are central to our culture and we all have a sense of what they look like and what they do. We use pictures like this all the time. As I noted in the preceding chapter, a great deal of our information about our world comes from these images, and all manner of specialist professions employ photographic documents in their work. Despite the evident importance of the document, however, there has been remarkably little critical attention paid to

it. The exception is Molly Nesbit's account of the photographs made by Eugène Atget at the turn of the 20th century.

Atget was not an artist, he made images of Paris for others to use, particularly some of those engaged in the skilled Parisian trades: theatrical designers, metal workers, illustrators, and those who worked off nostalgia for 'old Paris'. He didn't claim anything special for these images. When the Surrealists wanted to publish one of his

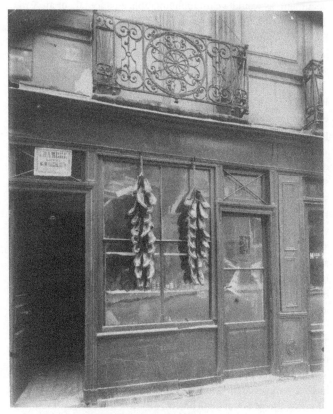

4. Eugène Atget, *Balcon, 17 rue du Petit Point*, 1912–13

pictures in their magazine, he declined any credit, adding 'These are simply documents I make'. Nesbit describes Atget's document as a 'nonaesthetic', workaday form, with two key features: firstly, it is a practical, utilitarian image; secondly, it is built on 'openness'. The document is always defined by its viewer, who brings his or her specialist requirements to it. For those who employed Atget's images, aesthetic significance was of little or no relevance. Information, content, detail, and use are what count in documents. According to Nesbit, 'an architectural photograph would be called a document, as would a chronophotograph, a police i.d., or an X ray'. The document, then, had no absolute form: the same image might be used by different specialists, and so it had to be open to interpretation. Atget was skilled in creating images that served several constituencies.

However, some key characteristics of the document had been established well before Atget. Historians of science have recently paid considerable attention to investigating the category of 'objectivity' – a key concept in the functioning of the photographic document and in other documentary media. Common sense suggests that objectivity is a self-evident part in the toolbox of science and other specialist forms of observation (the news media typically claim objectivity). However, historical scrutiny suggests that objectivity emerged as a component part of the new subjectivity for observers during the 18th and 19th centuries. We are all familiar with this conception of subjectivity from popular representations of the scientist: this is not the wild-eyed genius on a bad hair day, but the white-coated, emotionless, super-logical analyst.

The modern conception of objectivity began to take root as a response to the capitalist division of labour, which fragmented work and knowledge into increasingly specialized portions. Some intellectuals responded to the challenge of specialization by adopting the values of detachment, disinterestedness, and self-effacement, thereby asserting a stance seemingly outside particular

interests. This conception of objectivity entails eradicating all traces of the observer, which are seen to interfere with the process of recording data. This point of view presents observation as an activity independent of actual observers and their personal investments.

The long-standing tussle between scientific investigators and their illustrators offers one clear example of this process. Before photography, documents were obtained for scientists (or natural philosophers as they were called) from artists, but the men of science often disagreed with draughtsmen about what could be seen and how it should be depicted. The men of science opposed, what they saw as, the personal vision and aesthetic preferences of artists. When the French Interior Minister announced the invention of photography to the Chamber of Deputies in 1839, he noted that it would enable the traveller, archaeologist, and naturalist 'to note what they see, without having recourse to the hand of another'; similarly, William Henry Fox Talbot – the English scientist credited with the discovery of photography – dreamed of an automatic apparatus that would do away with his dependence on artistic skill.

Photography, and in particular the photographic document, slotted neatly into this new vision of objective observation. Throughout its history, the camera has repeatedly been seen as an objective machine that captures information without any interference from the artist. We have already heard the sleeping photographer joke; in the early years of photography this was an often repeated theme: it was assumed that the sun made the picture, or the camera did, or even that the object in question depicted itself (Talbot spoke of his country pile, Lacock Abbey, as the first building 'that was ever yet known to have drawn its own picture'). In each variant, the image emerges without any conscious involvement by the photographer. In this story, the camera figures as a model worker who never tires or loses attention, doesn't demand more wages or go on strike. The document is, in its essentials, an objective form, which is deemed truthful because it seems to be independent of the values of actual

observers. In this light, photographs can seem neutral witnesses to
events.

Self/Other

The document was plain and artless; it was designed to be
transparent so the viewer could look through its surface and
concentrate on the things depicted. In the production of documents
the camera is usually located in a frontal, straight-on position,
providing as much detail as possible; the subject frequently fills the
frame. Honoré Daumier's *Parisian Sketch* of 1853 presents an
anatomy of this form.

Daumier depicts two different Parisians and the way they
comport themselves for the camera. The 'natural man' faces
squarely up and stares into the lens – the resulting image will be

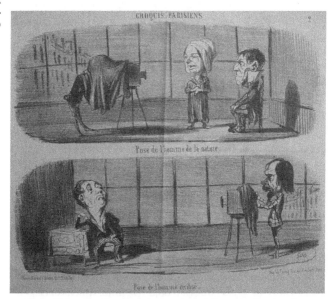

5. Honoré Daumier, 'Croques Dramatiques', from *Le Charivari*, 1853

direct and unadorned. 'Civilized man', in contrast, adopts an artfully contorted position and gazes thoughtfully into space; his stance requires the support of the draped table. The image – all fancy pose and deep shadow – is designed to convey dreamy reflection and sensitivity. It is, of course, a good joke about Parisian types – the no-nonsense, brutish bourgeois and his affected, artistic cousin – but it is also an excellent rendering of the difference between documents and pictures. Once again, these images assume their characteristic meanings through their contrast.

Photographic documents have been employed to do many things, but it is instructive to turn briefly to the second half of the 19th century, when they were increasingly put to work by a wide range of state institutions and private organizations. In each case, the photograph was thought to produce an objective record, rather than an interpretation, or presentation, of information. One reason that this focus is useful is that it draws out the extent to which photographs depend for their meanings on networks of authority. The image supplies little in itself. What counts is its use and the power to fix a particular interpretation of the events, objects, or people depicted. Some people, and especially some institutions, have much more clout in this process than others do.

As John Tagg and others have argued, during the second half of the 19th century, through depicting 'abnormal' cases, or those viewed as deviant – criminals, the sick, working people, colonial subjects, and so on – photography contributed to the definition of those who society classed respectable and normal. In the new intellectual disciplines and practices that developed during this period – psychiatry, anthropology, and others – the photograph was employed to identify and define new objects of knowledge; to categorize new specimens. One recent author, preparing a study of photographs made in Africa between 1840 and 1918, observed that his search for images led him not into art museums, but to museums of science, the archives of governmental ministries, professional societies, and former colonial companies.

This process of investigation was built on a hierarchical vision, because in each case the person with the camera had the social authority, or money, to arrange and pose others for scrutiny: the photographer John Thompson, for instance, noted in 1873 the 'trifling sums' that he paid to poor Chinese people for 'the privilege of taking such subjects'. Some people were authorized to look; others were looked down upon. The pictures made of medical bodies, criminals, colonial subjects, and slum dwellers were never intended for the gaze of those who appeared in the photographs; they were designed to receive the attention of 'specialists'. Typically, these photographs were made in one place – the place where people of this kind were to be found – but circulated in metropolitan centres, in government departments, law courts, or professional institutions. Under these conditions, to be seen and pictured is to be caught up in the definitions of others deemed more expert or authoritative. The archives of photographs produced at this time were, in the first instance, subject to this kind of specialist, authorized attention. The images of the sick body were studied by medical students and surgeons; those of prisoners by detectives. Nevertheless, these archives seeped into wider circulation. For instance, the images made by Dr Hugh Diamond of female inmates under his supervision at the Springfield asylum were issued as lithographic illustrations in John Conolly's book *The Physiognomy of Insanity* in 1858.

Let me briefly examine a few examples from, what Tagg calls, these 'archives of subjection'. As I noted in the preceding chapter, before the advent of photography police identification of suspects or repeat offenders relied upon eye-witness description and memory. Fingerprints emerged as a means of identification only during the late 19th century. When fingerprinting was combined with photographs, a powerful new technology of identification and surveillance came into being. (We tend not to pay much attention to the filing cabinet, but it played a significant role in this new system.) Perhaps surprisingly, some time passed before photography was systematically employed by the police and prison network. Early

photographic documents of British prisoners reveal lack of standardization: frequently men and women appear in their own clothes; there is neither regulated camera distance or position, nor any systematic pose; sometimes the images are presented in ornamental frames. Surprisingly from our perspective, initial prison photography was modelled on the middle-class portrait. When police photography really took off in the 1870s, it was much more regulated, with standard poses, camera positions, and so on. The documents produced were intended for comparison and differentiation.

However, there were two distinct tendencies involved at the time; the 'police archive' was torn between these rival models. On the one hand, was the idea of the 'criminal type', supposedly predetermined to offend against the law by his or her wicked nature. In this vision, the criminal was a kind of degenerate biological category. As Allan Sekula and others have shown proponents of this conception adhered to a 'physiognomic' model – the belief that interior mental states, or personality traits, are manifest in the characteristics of the body. Advocates of this pseudo-science attempted to produce images that would reveal innate criminal characteristics; photography was an obvious resource for this approach. In his book *L'Uomo delinquente* of 1876, Cesare Lombroso produced a range of portraits purportedly showing criminal types; more elaborately, during the 1880s, Francis Galton developed a technique of exposing multiple portrait negatives to form one image so that shared characteristics came through to give, what he claimed, was a physiognomic likeness of the inherent criminal type. At the opposite extreme to this generalizing trend was a particularizing vision, which sought to individuate criminals. This approach, identified with Alphonse Bertillon, who directed the identification service of the Parisian Préfecture de Police from 1882, produced records of individuals that combined numerous photographic details of the body with careful measurements of the ears, the length and width of the nose, the distance between the eyes, and so forth. In both approaches, the photograph traces the

marks of the body that would be used to identify and discipline those who offended against the existing norms of behaviour.

My other example of photography in the service of professional authority is drawn from the encounter between Western colonizers and the colonized peoples. The photographic document was one means through which the colonial powers envisaged their difference from their colonized subjects. These images originate from various sources: from the personnel attached to the colonial departments, missionaries, individuals working for colonial companies, and military officers. Anthropology, institutionalized during the 1840s, became increasingly concerned with photographic documentation during the 1870s. During this period, images of the colonial Other are overwhelmingly predicated on an idea of essential racial difference and a concomitant vision of racial superiority. Some observers were undoubtedly attracted to the way of life they recorded, which they imagined to be less repressed than Western society, but a basic hierarchy held.

Two different tendencies can also be discerned in the colonial archive. The first is based on a comparative method and follows some of the themes we saw in the police vision. This view, which was again physiognomic, saw the traces of racial difference on the body: cultural difference was here reduced to physical distinction (which was itself petrified and over-generalized). Photography played an important role in collecting images of different 'races', which could be anatomically compared and contrasted. In 1869, John Lamprey systematized this comparative approach by photographing the body against a gridded ground and establishing rules for camera distance, angle, and so on.

This method was designed to enhance comparison of the various specimens. Despite the seeming objectivity of this project, it was steeped in colonial ideology and illicit desire. The naked body of the colonized subject was scrutinized and displayed in a manner that would have been deemed entirely inappropriate for that of its

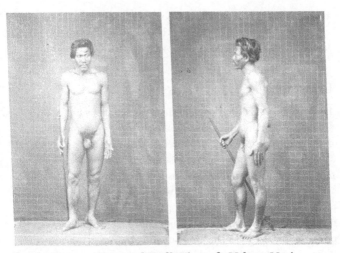

6. John Lamprey, 'Front and Profile Views of a Malayan Man', c. 1868–9

colonialist counterpart. The images collected in this way were employed to sort and sift humanity – at the far end of this process lies 'race theory', genocide, and various forms of 'ethnic cleansing'.

The second tendency involved projecting the fantasy of an ethnographic Other thought to be outside of modern society, indeed outside of time. The culture of the colonized was thought to be locked in an eternal past and deemed incapable of change or dynamic transformation. There are plenty of examples of this kind of ethnographic photograph: African farmers posed for a hunt; people stripped of modern Western dress and arranged in traditional costume, and so on. Similarly, postcards circulating from colonial Algeria in the early 20th century purport to depict that which they could not possibly show: the closed space of the harem. In photographs of this second type, colonial fantasy mirrors itself – the image embodies the observer's imaginary conceptions rather than any external conditions. Photography was employed from the later 19th century in a wide variety of archives, and each was subject

to the authority of a new type of observer: a professional middle-class expert who lived by (usually) his claims to education, specialist knowledge, and trained, objective vision.

Documentary

Left like this, the document appears as an invidious image that serves powerful interests. But, as we saw earlier, documents are, by definition, open to diverse interpretations and uses. The 'archives of subjection' embody one kind of institutional use for documents. But other people and other institutions have cast them in other roles. We need to approach this subject with some sense of the contradictory possibilities in play, particularly as the document was transformed into documentary. The term 'documentary' was probably first used by John Grierson in 1926. Grierson wrote that Robert Flaherty's ethnographic film *Moana*, 'being a visual account of the events in the daily life of a Polynesian youth and his family, has documentary value'. (He was to become a central figure in organizing and promoting the film movement he described.) Documentary is an incredibly elastic category – perhaps even more so than 'document' – which is frequently used to describe war photography, photojournalism, forms of social investigation, and more open-ended projects of observation. It covers commissioned work (for newspapers, magazines, or books); pictures taken without direct commission, but that subsequently appear in some commercial format; and consciously planned books or exhibitions. It is not uncommon to find a picture made in one context migrating to another: say, a photograph by Weegee made for a news story appearing in an exhibition, or a book representing his work as a photographer who has been awarded the status of *auteur*. It can seem very difficult to establish any common link connecting these disparate activities under the collective heading of 'documentary'.

Nevertheless, we can detect some characteristic features that unite seemingly diverse documentary photographs. One approach to this

problem, and it has been a prominent one, claims that documentary, in all its forms, entails an objective, unmediated record of facts. Documentary is said to provide its viewers with direct access to truth. In his pioneering book on the subject, William Stott stated: '[t]he heart of documentary is not form or style or medium, but always content'. As we have seen, this is an argument rooted in the idea of the mechanical arts and the related conception of a detached observer. Most often, this approach is predicated on a range of negative injunctions: no colour (black and white); no cropping; no retouching; no posing, staging, or introducing extraneous objects; no additional lighting or dramatic light effects. What is left unsaid in this account is that some institutions or powerful individuals have the resources and authority to decide what counts as true or objective. As Tagg noted, if a photograph of the Loch Ness monster is to count as evidence for its existence it matters whether it was made by a private enthusiast or by the military. The site of its circulation matters just as much. In practice, the truth content of images is always open to dispute and can be challenged by contending interests. To take only one well-known example: in 1936, the American photographer Arthur Rothstein moved a sun-bleached steer's skull from a patch of grass to cracked and parched soil, thus creating an iconic image of the effect of draught on small farmers. When this shift of site emerged there was a conservative outcry. This was not an objective record, the critics said, but an image that had been tampered with or set up – it was not a documentary record, but 'propaganda'. In this instance, the presence of the photographer was deemed to disqualify the 'content' of the image.

There is another approach to documentary, though, which seems more defensible and more interesting. The art-photographer Ansel Adams criticized what is probably the most famous documentary project, the Historical Section of the Farm Security Administration, which produced 270,000 photographs of American society between 1935 and 1943. Adams claimed that those working for the FSA (including, among others, Arthur Rothstein, Dorothea Lange, and

Walker Evans) where 'not photographers' but 'a bunch of sociologists with cameras'. There is a point here: the two central subjects of documentary are war reportage and social investigation. Evans himself outlined, for his boss at the FSA, an itinerary for a trip through the Southern States of America in 1935:

Still photography, of general sociological nature.

First objective, Pittsburgh and vicinity, one week; photography, documentary in style, of industrial subjects, emphasis on housing and home life of working-class people. Graphic records of a complete, complex, pictorially rich modern industrial center

It is important to grasp that Adams was committed to art-photography as a form of self-expression: for him, significant photography involved the production of pictures, not mere records or documents. In one sense, Evans echoes this perception, referring to photography of a 'sociological nature', but there are other features from his itinerary that suggest another conception: 'graphic records' and, crucially, 'documentary in style'. The latter idea represents an early articulation of a distinction that Evans returned to during the 1970s, when he stressed the difference between 'documentary' and what he termed 'documentary style'. Documentary, he said, was not a very clear idea because 'an example of a literal document would be a police photograph of a murder scene'. What Evans, and those others we would label documentary photographers, did was work in a 'documentary style'. Evans's distinction is not quite as secure as he maintained, but it draws attention to an important point. Documentary photography is an aesthetic mode or a style. Often the champions of documentary deny this, claiming their work is styleless, objective, and direct. Nevertheless, this work is always an approach to photography; a mode of representation predicated on the form of the document. This style is characterized by two closely related factors: anti-subjectivism and a gaze that looks outward to the world. (In his way, Adams registered this, but he was committed to the inward

and the subjective.) Seen in this fashion, documentary
seems more interesting and more defensible.

Technologies

In an important sense, documentary as we know it only really
emerged in the later 1920s and 1930s. When Roger Fenton
produced his photographic record of the Crimean War in 1855,
the images he made consisted of posed portraits or immobile
scenes.

There are no dead or wounded bodies among his images and no
photographs of 'action'. Fenton's most famous photograph – *The
Valley of the Shadow of Death* – depicts a rough track strewn with
cannon balls, but no other signs of human presence. Ten years later,
a lot more corpses are evident in the photographs from the
American Civil War. But it was more than 50 years before
photographers could really depict dynamic action. For instance,

<div style="text-align:right">Documents</div>

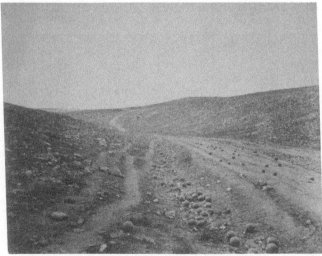

7. **Roger Fenton, *The Valley of the Shadow of Death*, 1855**

Robert Capa's photographs of the Spanish Civil War of 1936 puts the viewer right in the thick of events. His *Death of a Loyalist Soldier* apparently captures the instant of this man's death and is taken a matter of yards from the event.

Capa's most famous dictum was '[i]f your pictures aren't good enough, you aren't close enough'. The British authorities were concerned to ensure that Fenton did not record anything that would be bad for morale, but even had he wished, he could not in fact have made a photograph like *Death of a Loyalist Soldier*. Fenton worked with a heavy, large-format camera that required a tripod, resulting in a static point of view. What is more, the wet-collodion glass plates he used required rapid processing once exposed before they dried (he took a darkroom mounted on a horse-drawn wagon with him into the field). His technology almost guaranteed a fixed and formal image.

Some transformations in photographic technology occurred in the intervening period, but the key changes took place from the mid-1920s. From this period, small lightweight cameras with good

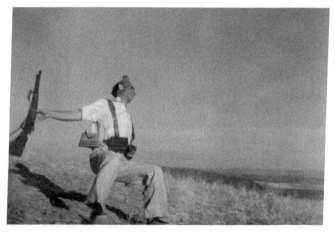

8. Robert Capa, *Death of a Loyalist Soldier*, Spain, 1936

lenses became available. At this point, many photographers began to use an Ermanox, a small-format plate camera, which could be held under certain conditions. Although its use did not become widespread until the 1940s, the key change came with the creation of the Leica camera, originally created to test exposure times for movie film. The Leica transformed possibilities in photojournalism. Firstly, it utilized 35-millimetre movie film in small metal canisters; this considerably reduced camera size and meant that the photographer could carry and expose a large number of frames with minimal time elapsing between them. (Some photographers working today expose 300 or 400 frames a day.) Secondly, the small format enabled photographers to work in a mobile, fluid way with the camera held at eye level (itself an innovation – prior to this time most cameras were positioned lower). At the end of the 1920s, flashbulbs were introduced, allowing work in poor light conditions (flash photography had previously involved combustible magnesium powder in a dish – a flash in the pan – resulting in an intense burst of light and dense smoke). Photographers could now photograph events from the inside and often went unobserved. The number of frames possible also meant that a premium was no longer placed on getting everything right in advance, since the best image could be selected later from among the numerous exposures.

Fenton's images provided the basis for engravings in the press. This was a laborious process, taking one or more engravers days to produce a plate from the original image. The images also appeared in limited deluxe folio editions after his return from the war. His material was neither rapidly nor widely disseminated. Capa's photographs, in contrast, soon appeared in magazines and papers across the world. Another technical transformation had made this possible. Before the 1880s, it was not commercially feasible to reproduce photographs and type on the same page. Photo-printing systems were available a decade earlier, but the half-tone screen, developed during the 1880s in Europe and the USA, came to dominate newspaper and magazine reproduction until the

introduction of digital technology a century later. Half-tone screens are made by interposing a sheet of glass marked with a grid between a photographic negative and a zinc plate rendered sensitive to light. In this process, a photograph is transformed into an image composed of numerous dots in various sizes, which can then be printed in ink, allowing it to be combined with type. This system created the conditions for photography's emergence as a mass-image form. It was, however, slow to catch on, partially, at least, because hand-engraved images continued to signify quality. The press employed photographs on a regular basis only from the beginning of the 20th century. The first paper that was illustrated throughout with photographs, *The Daily Mirror*, appeared in 1904. When photomechanical printing did become widespread, it reinforced the seemingly agentless 'objectivity' of the press.

It was during the later 1920s and 1930s that the important mass photo-magazines predicated on a new educated, urban audience appeared. These were publications structured around photographic stories that covered topical news events and everyday life. In 1935, it became possible to send photographs by telegraph, images taken a great distance away could then be sent to the home publication and printed more-or-less simultaneously with the events they depicted. These magazines became one of the most important cultural forms of the 20th century. Many of the central innovations in the photo-magazines arose in Germany. By 1928, the *Berliner Illustrierte Zietung* sold 2.2 million copies. The Nazi takeover of the country in 1933 had the effect of dispersing key editors, photographers, and layout specialists throughout the world. In 1936, the American publication *Life* appeared, selling nearly half a million copies. At the end of 1938, *Picture Post* was launched in Britain (with refugees from Hitler prominent among the staff). The French photo magazine *VU* commenced publication in 1928, and *Paris-Match* was launched in 1949. *USSR in Construction* (in three languages), published from the late 1920s, embodied a Stalinist vision of socialism in one country, while employing iconic images and a dynamic layout. *Arbeiter Illustrierte Zeitung*, a picture magazine

allied to the German Communist Party, which regularly featured photomontages by John Heartfield, along with investigative photojournalism, reached a circulation of half a million. After Hitler came to power it was published outside Germany and clandestinely smuggled into the country. In 1951, *Drum* appeared in South Africa: this was an important magazine that employed black writers and photographers and which was extensively read by a black urban audience. It is said that, after the Cuban revolution, Fidel Castro declared he wanted something similar to *Life*, and *Revolución* was born.

The documenting photography that appeared in these magazines was frequently infused with a sheer sense of visual wonder. The editorial in the first issue of *Life* declared that its aim was to enable its audience:

> [t]o see life; to see the world; to eyewitness great events; to watch the faces of the poor and the gestures of the proud; to see strange things . . . to see and take pleasure in seeing; to see and be amazed; to see and be instructed.

In an important sense, despite the differences in the ideology of the photo-magazines, this editorial provides a programmatic statement for the new documentary work that emerged in the 1920s and 1930s. Documentary photographers put the new technologies to work in recording things that had not previously been depicted. This tendency was particularly evident in the early picture magazines' fascination with the first published image of this or that. *Picture Post*, for example, might feature 'the first full picture story of an operation', or 'the only photograph ever taken inside the high court'.

Much documentary photography, especially between the world wars, was conceived as a poetic form. (Grierson saw documentary in this way: the film *Night Mail*, which he produced in 1936, had a score by Benjamin Britten and a commentary by the poet

W. H. Auden.) Many key documentary photographers – including Walker Evans, Henri Cartier-Bresson, Humphrey Spender, Brassaï, and André Kertész – thought of their work as a new kind of poetry. In this manner, much documentary photography combined a campaigning vision with an aesthetic of the everyday. In part, at least, this conception stems from the emergence of documentary photography alongside Surrealism. Documentary photographers were interested in finding the extraordinary in ordinary life. Rather than high-flown subjects, the vision focused on the way shadows fall on empty coffee cups, life on the streets of the modern city, or the oddities associated with popular leisure. Themes from everyday life played a particularly central role in the documentary vision before the mass commercialization of popular culture, which really took hold, if unevenly, after World War II.

For the best part of 50 years, these magazines, and many others like them, were a feature of the cultural landscape, providing outlets for investigative photojournalism and documentary. Some have suggested that television killed the photo-magazine. However, what seems to have been more particularly responsible for their demise was the spread of commercial television, which stripped them of advertising revenue. By the 1970s (France seems to have been an exception), these magazines had been replaced by the Sunday supplements, more or less entirely geared for advertisements.

Subjected

Documentary has always been closely linked to the study of social class. During the 1970s and 1980s, documentary was interrogated by both practising photographers and critics. Two overlapping themes emerged. One component developed from a reconsideration of 19th-century photographers who were seen as important figures in the pre-history of documentary: figures such as Thomas Annan, who depicted slum conditions in Glasgow in the 1860s; John Thompson, responsible for images of London street life in the

1870s; and Jacob Riis, who, during the 1880s and 1890s, produced an extensive body of photographs of working-class 'slum dwellers' in New York. The same physiognomic ideas we encountered earlier were applied to the study of working people. In a period when the city was rigidly zoned by class, social investigators saw it as their mission to illustrate the lives and habits of working people and to reveal the threat they posed to the health and welfare of nation and empire. Photography proved an important tool in this process. Working people – often referred to at the time by social investigators as 'slum dwellers', or 'the poor' – where represented by these photographers as a problem (almost as a race apart), requiring regulation by those in authority. Riis exhibited his pictures in various formats, including magic lantern displays for the New York elite, dramatizing the menace represented by this unseen urban horde. As I have suggested, this critique of photography in social investigation was extended to mainstream documentary photography, and there are plenty of reasons for doing so. Before instigating the documentary 'Mass-Observation' project, called 'Worktown', dedicated to the study of people in the North of England in the 1930s, Tom Harrison had been working as an anthropologist. He drew a direct comparison between the two forms of observation, noting:

> The wilds of Lancashire or the mysteries of the East End were as little explored as the cannibal interior of the New Hebrides, or the head hunter hinterland of Borneo. . . . In particular, my experience living among cannibals in the New Hebrides . . . taught me the many points in common between these wild looking, fuzzy haired, black smelly people and our own, so when I came home from that expedition I determined to apply the same methods here in Britain.

There is a palpable distance here between 'us' and 'them'. There are lots of examples of this kind, which suggest that documentary photography might be understood as a kind of reconnaissance operation generating intelligence on people who had previously escaped official attention.

The second aspect of this critique focused on the 'humanism' and universal assumptions embodied in the documentary style. While documentary photography displayed a generalized sympathy for 'the people' and often took the poor and the destitute for its subjects, it was argued that it tended to obscure real differences, particularly differences in power, between social classes. Documentary purveyed a generalized sympathy for the poor and downtrodden, but it offered precious little in the way of analysis or critique; only rarely did it draw to light the structures sustaining these manifest inequalities. It focused on the visible signs of poverty – ragged clothes, dirty children, crumbling houses – and did little to highlight the causes. The same criticism is levelled today at charity images. Indeed, the critics of documentary argued that this was a condescending vision, akin to charity; it represented the plight of the poor – whether in Western cities or rural Africa – so that the powerful might act, but it did nothing to enable the people depicted to represent themselves, or take control of their destiny. In this sense, all too often documentary depicts people as passive victims. At worst, the poor and destitute are photographed in order to put the humanity of the photographer on display.

These are powerful criticisms of some key trends in documentary photography, but they are not the whole picture and, in our cynical age when a concern with documentary and class seems deeply unfashionable, this argument appears overbearing; it homogenizes diverse approaches and obscures some important and valuable aspects of the documentary tradition.

One problem with the critique of the documentary mode is that it risks over-emphasizing the image at the expense of its actual use. What people make of documentary images does not necessarily coincide with what they were intended for. The attention paid to social class in documentary photography during the 1930s provided an impetus for a wide-ranging discourse about the condition of society: this debate contained different voices, including those who did not share the middle-class reform politics of documentary's

protagonists. The depiction of the unemployed or the working poor can be seen, in this sense, as just a starting point for a fierce struggle over definition. The outcome of that discussion is not predetermined by the images themselves. John Roberts has observed that the decline of documentary – or at least the plummet in its prestige – has coincided very closely with a retreat from class politics among the Western intelligentsia. Social class remains as powerful a determinant on our lives as it ever was; indeed, all the statistics suggest class distinctions have been entrenched over the last 20 years, but they seem much less visible than they once were. The absence of documentary attention is a contributing factor to the current lack of debate on this issue.

Alongside the intelligence agents, anthropologists, and philanthropic reformers, there have also been many photographers who have seen themselves as contesting official accounts of events. To take just a few examples: in the early 20th century Lewis Hine made photographs to be used in the campaign to end child labour in American factories, mines, and sweatshops; during the 1920s and 1930s, Tina Modotti recorded the Mexican revolutionary struggle from the inside – her pictures featured in the radical press; in Britain during the 1930s, Edith Tudor-Hardt worked closely with members of the National Unemployed Workers' Association. Documentary photographers in Latin America have played varied and active roles in popular resistance, while Ernest Cole's book *House of Bondage* is undoubtedly one of the most powerful condemnations in any medium of apartheid South Africa. Today, whatever else may be said about their work, Susan Meiselas and Sebastião Salgado see their pictures as contributing to the global struggle for social justice.

In any state that will tolerate them, there are still plenty of small agencies staffed by oppositional and committed documentarists.

Documentary, in some of its forms, can be seen as an analytic vision

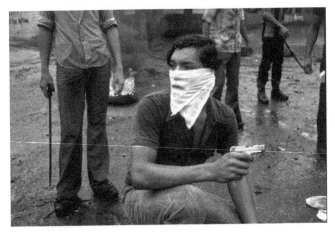

9. Susan Meiselas, *Street Fighter in Managua*, 1981

capable of great critical acuity. The powers that be have long understood this potential and have repeatedly censored documentary images. In the case of dictatorial regimes, with a vested interest in their nefarious deeds going unrecorded, this should be obvious enough. But liberal-capitalist states also increasingly attempt to police the circulation of documentary photographs.

A few examples will serve to make the point. During the seven-year occupation of Japan at the end of World War II, the US administration banned the publication of any images relating to the atomic bombs dropped on Hiroshima and Nagasaki. It was only after the US departure that Yosuke Yamahata, Ken Domon, and Shomei Tomatsu were able to circulate their important photographic record of these events. Despite an initially positive response from the US government towards the recording of the Vietnam War, which it saw as good publicity for the fight against communism, photojournalists played a significant role in swinging public opinion away from support for intervention. Larry Burrows, David Douglas Duncan and Philip Jones Griffiths, Don McCullin,

and Tim Page all produced important photographic studies that cast the conduct of the war in a starkly negative light. North Vietnamese photographers Vo Anh Khanh, Minh Truong, Doan Cong Tinh, and others, who worked under incredibly difficult conditions, also produced important documentary records of a peasant army confronting a superpower. Among the many telling photographs from this imperialist war, Eddie Adams's image of a Saigon chief of police summarily executing a communist suspect in the street had an enormous impact on public opinion; so did the pictures of the My Lai massacre, in which US soldiers killed men, women, and children. The photographs of this atrocity were smuggled out of Vietnam and circulated by the US army photographer Ron Haeberle (one image became the basis for the widely seen poster *Q. And babies? A. and babies*).

Governments now appear to have learned their lesson. During the Falklands/Las Malvinas conflict in the early 1980s, the British government allowed only official images to appear in the media; in the recent invasion of Iraq, journalists and photographers were 'embedded' with military units; while the US military has subsequently sought to prevent the disclosure of 'trophy' images, which reportedly depict the abuse of Iraqi prisoners, for fear that they may be used as 'propaganda' by the enemies of the occupation; they have also policed the publication of images of the American casualties. Documentary photographs often display events that some people would prefer remain unobserved; when they emerge, these images can become the locus of widespread debate and disagreement. The control of documentary photographs clearly still matters.

Chapter 3
Pictures

To speak of photographic 'art' is fraught with problems, not least because there are at least two, and possibly three, traditions out of which this category has been put together. Firstly, there is 'art-photography', stemming from the 1860s, which involves photographers making pictures that claim the status of art. This tradition includes quite diverse tendencies stretching from 'trick' photography to the injunction against any manipulation; from soft focus to technical precision; from subjectivism to objectivism. Secondly, there are lots of examples of artists using photography (though, as one colleague wryly noted, no one ever speaks of 'photographers using art'). Thirdly, 'street photography' or *auteur documentary* is often grouped with art-photography. In an important sense, the idea of an art of photography is an 'invented tradition'. Powerful institutions, curators, and collectors have drawn images from contexts as diverse as campaigning publications and scientific archives to weld together a tradition and, not insignificantly, generate a commodity market. Attempts to knit this material into some coherent garment tend to unravel, as different contexts of use and value pull in different directions. Nevertheless, in the last 25 years artists have become increasingly aware of the histories of photography, and some of the most prominent artists practising today – Jeff Wall or Thomas Struth – work exclusively in photography. This chapter provides a brief overview of some of the trends (and a few contradictions) in art-photography.

The 19th century

As I suggested in the previous chapter, the language of art was integral to photography from its inception in 1839; wealthy amateurs dabbling with photography, for example, often modelled their activity on print connoisseurs. Nevertheless, it was 20 years before serious claims were made for an art of photography. These claims coincided with the rise of a body of professional photographers, and were articulated in meetings of their societies, and appeared in their specialist publications. Photographers had to fight an uphill battle: the prevailing belief had it that photographs emerged automatically from a soulless machine. The camera produced documents not pictures. In both England and France, for much of the 19th century, this was the prevailing legal view. The law, when called upon to adjudicate on copyright, tended to assume that the photographer was a passive attendant on an apparatus (much like a worker) who could not be a copyright owner. Copyright was often attributed to the commissioner of the picture or owner of the property depicted; in some cases, photographers were even denied the right to use their own negatives. Photographers had to work hard against this conception. Here is Antoine Claudet, a French photographer domiciled in England, writing in 1861:

> Photography indeed can invent, create, and compose as well as copy. In fact, particularly in portraiture, the machine copies what the true artist has invented, created, and composed, which could never have been copied or represented if the photographer had not possessed genius.

What is interesting here is the extent to which art – which for Claudet entails invention, composition, and genius – is entwined with the negative case of the document or copy. Throughout its history, photographic art has been intimately connected with this demonic twin: sometimes it has struggled to cast it off, and at others it has entered into a pact with it. In both instances, however,

photographic art retains a determining relation to the idea of the automatic copy, or objective document.

During the 19th century, art-photography meant, first and foremost, asserting the active presence of the photographer. The dominant historical perspective on 19th-century photography has, however, focused on the idea of a 'new medium'; a proposition first advanced by Elizabeth Eastlake in 1857. The problem, though, is that Eastlake's suggestion is read anachronistically from the perspective of the modernist aesthetics that held sway from the 1920s until, at least, the 1970s. Photography, modernists claimed, represented a new way of looking at things – a 'new vision' – that broke with traditional pictorial forms, creating new modes of composition and offering new visual experiences. The new vision, or camera vision, meant working with those characteristics that were specific to the medium of photography. This argument suggests that the camera shows things in a new and unique way: clear, precise, without selecting; with novel framing effects and new vantage points. This attitude underpins the idea that photography provided the source for the unorthodox compositions of Impressionist painter Edgar Degas, who, from the mid-1870s, often shifted the principal subject to the edge of his pictures, sliced through figures, adopted unusual points of view, and positioned objects between the viewer and the focus of attention. However, the photographic effects that are supposed to have influenced Degas really surface with the amateur images produced at the end of the century; similarly, Eastlake's 'new medium' was not a new way of looking, but a rather traditional one. For her, the photograph was not a work of art, but a document that could be used by artists.

In fact, the kind of picture associated with Degas, with its empty centre and lopped-off heads, would have seemed scandalous to 19th-century photographers, who took their models from the mainstream paintings exhibited in Academy or Salon. Photographic composition during this period featured integral figures and objects positioned at the centre of the image; the framing edge of the

photograph bound the space into a coherent whole. In 1869, the English photographer H. P. Robinson described how this kind of picture would look. He claimed that in good photographic composition:

> the principal object, must come out into the strongest relief; the rest must be subordinate; and thus we should obtain unity which is necessary to pictorial effect.

In English Academic theory, the relation Robinson described was known as 'hierarchy' and 'subordination'. This conception assumed that the most significant figure or object should be rendered in much greater detail than the rest of the picture, so that the viewer's attention would be directed to the compositional centre. Some photographers attempted to use a differential focus to attain this effect. In France, a little earlier than Robinson, the photographer Gustave Le Gray articulated a comparable account based on a 'theory of sacrifices'. Photographers followed Academic rules partly because this was the version of the picture available to them, and partly to distance themselves from the idea that they were mindless and mechanical copyists. As with the document, definitions of photographic pictures emerged from this long-running division between the mechanical and the liberal arts.

In the main, photographers did not attempt to follow Academic painters in creating imaginative scenes from the Bible or ancient history (although some were prepared to have a go). As Robinson put it, the painter could 'imagine new worlds' and depict 'angels and cherubim' or the Last Judgement without offending taste. But, he said, when 'the photographer [. . .] attempts to do so, he holds his art up to ridicule and contempt'.

Photographers, in the main, confined themselves to the lower genres of art: still lifes, moralized scenes from everyday life, artistic portraiture, and picturesque views. Some, though, went further. Oscar Rejlander, and then Robinson, developed a technique of

'combination printing', in which a photograph was produced from multiple negatives: Rejlander made his *Two Ways of Life* (1857) from 30 separate negatives, while Robinson's *Bringing Home the May* (1862) was compiled from 9 negatives. This technique was obviously a very difficult process to master, requiring precise and laborious work in the darkroom to disguise the joins. Combination printing enabled Rejlander and Robinson to produce elaborate compositions that followed the rules of art. The sheer effort involved also allowed them to suggest that their pictures were not mere copies, but the result of artistic skill, intelligence, and culture. Many were unconvinced: the parts seemed to be lit from different directions; shadows did not coincide with the principal light source; the diverse figures, or the figures and the *mise en scène*, did not seem to mesh together. One critic claimed that Robinson's pictures were more like 'patchworks' than artistic compositions. Gradually, both Rejlander and Robinson abandoned this technique, while continuing to produce elaborately staged genre scenes.

Perhaps Julia Margaret Cameron pursued the idea of photographic art more inventively than anyone else during this period. Her pictures are much simpler, consisting of just a few figures artfully posed against a vague background. However, what is really distinctive about her work is that she employed an all-over soft focus rather than highlighting the most significant part of the image (for this reason, the photographic establishment disliked her pictures). But, in the end, Cameron's work is not so different from those around her; her subjects are drawn from the Academic repertoire and she made full use of the dressing-up box.

Towards the end of the 19th century, there was a concerted effort to establish photography as a creative art, which coalesced into the international movement known as Pictorialism. An exhibition held in 1891 by the Vienna Camera Club, with the express aim of showing only artistic work, is usually seen as initiating this trend. In its wake, a number of independent photo-associations developed in

Europe and North America as splinter groups from the established societies. Unlike the existing groupings, Pictorialists, despite differences, were single-mindedly dedicated to the cause of art-photography.

The Pictorialists drew their subjects and compositional modes from the existing pictorial arts. They were particularly attracted to the hazy aesthetic effects of the artist James McNeil Whistler and to fashionable Japanese prints. Pictorialist art was self-consciously 'arty'. Photography is a process that allows for the production of multiple images from the same negative. When prints are made by hand from the same negative, they inevitably vary somewhat, but, in principle, the same image can be reproduced in large numbers. In contrast, Pictorialists went to great lengths to produce unique, handcrafted pictures that corresponded to established artistic models – ink or wash drawings and etchings. To this end, often the negative was extensively reworked with brush or pencil to suppress unwanted details, change the balance of tones, add or remove highlights, and so on. (Frank Eugene used an etching needle to literally scratch away the details and features he did not want to appear in the final print.) The Pictorialists also adopted a soft-focus approach and worked to suppress detail, frequently using lenses adjusted to this end; they were drawn to atmospheric conditions that veiled the subject (mist, rain, and snow).

Many of them sought out difficult printing processes such as the gum brichromate process, platinum print, or bromoil print. Though not universally employed, the gum brichomate process is symptomatic of this sensibility. This process was invented in 1858, but was revived in the mid-1890s. To make an image, a paste consisting of gum arabic, pigment, and potassium brichromate was spread on paper; this was dried, placed in contact with a negative, and exposed to light, thus darkening the brichromate that bound the pigment. To bring the image out, the exposed paper coated in the paste was simply washed with water, removing layers of pigment. Using a brush or sponge, the photographer could

accentuate, or subdue, details and sections of the image. This 'stripping' technique gave a great deal of control over the final appearance of the image by determining how much pigment would remain; where to retain density and where to forgo it. Each print was, therefore, unique and revealed the singular touch of the artist. This process was used to virtuoso effect by Robert Demachy, Edward Steichen, and others. Gertrude Käsebier provides an excellent example of the Pictorialist approach. Käsebier has been described as the 'typical' Pictorial photographer.

She ran a professional portrait studio in New York, but also drew acclaim for her art-photography. Her approach involved taking a relatively standard, silver gelatin negative from a suitable subject; she then produced a print which she reworked with a brush, touching out unwanted details and subduing tonal variety. This print was then rephotographed and the resulting negative used to make a gum brichomate print.

10. Gertrude Käsebier, *The Road to Rome*, 1903

One important factor in the development of Pictorialism was the rise of mass amateur photography. In 1880, George Eastman launched the Kodak camera, which enormously simplified the photographic process and reduced the cost. The Kodak (a word adopted because it could be pronounced the same way in many European languages. It is, supposedly, an onomatopoeia for the noise made by the shutter) came ready loaded with roll film. This camera was not equipped with a viewfinder, so the photographer simply aimed in the general direction of the subject and made the exposure. When the entire roll had been exposed, the camera was dispatched to the Eastman company, which sent back the processed photographs and a newly loaded camera. With their slogan 'You Press the Button, We Do the Rest', Eastman made photography available to those who did not have the time, or interest, to learn how to develop and print images. This marketing strategy, exemplifying monopoly trends in capitalism, provided the pivot for an economic and cultural transformation, which shifted photographic image-making from the professional studio to the domestic sphere; commissioned work was similarly replaced by the sale of equipment and processing. So began what Pictorialist-in-chief Alfred Stieglitz called the 'photographing-by-the-yard era'. Not all amateurs depended on the Kodak system; some cheaper cameras required more basic competence, and many (male) hobbyists prided themselves on their technical ability – indeed for some, this was the point of photography. Nevertheless, the new breed of amateur snapper emerged from this business transformation.

Some Pictorialists (like Stieglitz) were wealthy enthusiasts, others (like Käsebier) were professionals, yet others still occupied a specialist niche in the amateur leisure market for photographic commodities; but they all marked their identity in opposition to the 'mass' snapper. As Stieglitz put it, the new hand cameras meant that 'every Tom, Dick or Harry could, without trouble get something on a sensitive plate'. This kind of photography, he felt, involved 'no work and lots of fun'. Stieglitz thought fun had no place in serious

art-photography. Many amateur Pictorialists took a different view; for them photography was wrapped up with day trips to the countryside and the new craze for bicycling. In each case, though, the efforts to make pictures, the studied composition, hazy effects, and laborious printing techniques, can be seen as a strategy of 'distinction' intended to separate Pictorialists from unskilled amateurs. In economic terms, this strategy involved a distinction between the luxury and the mass market; amateur Pictorialists occupied an intermediate position, as the target for specialist commodities.

In addition to his important role as a photographer, Stieglitz was, perhaps, *the* champion of art-photography. He was instrumental in establishing the two leading North American Pictorialist organizations, the Camera Club and the *Photo-Secession* (he edited, and largely funded, the former's magazine, *Camera Notes*). He also ran '291' gallery on 5th Avenue, New York, an exhibition space that showcased the work of Pictorialist photographers (and later gave European artists like Picasso and Matisse their first US exhibitions). But perhaps his key contribution came with the magazine *Camera Work*, produced between 1903 and 1917. This lavish publication, funded by Stieglitz, featured photographs, often printed from the original negatives on expensive paper, using the highest-quality reproduction techniques (such as photogravure). Stieglitz personally supervised the production process and controlled the appearance of the magazine, to the extent that he even designed advertisements. *Camera Work* was a luxury product (it never gained more than 650 subscribers) that signified craft quality and authorial attention in a mass-produced, shoddy world. Stieglitz believed that photography was not accepted as art because of the bad impression made by mass-produced images – whether created by commercial practitioners or amateurs having 'fun'. In contrast, he set himself the task of transforming photography into a serious cultural activity.

Pictorialism was to have a mixed legacy: despised by

photographers, theorists, and historians influenced by modernism, its principal impact was on amateur or mass taste. As late as 1943, the photographer Edward Weston complained that while 'Salon photography' no longer imitated watercolours or ink drawings, it continued to follow the rules of composition established in the pictorial arts. The sensibility of Pictorialism, if not the elaborate techniques, left a long shadow over amateur pictures and the general perception of art-photography.

The avant-garde

While the judgement of later photographers on the 19th-century art-photography would be harsh indeed, in reality the break with the predominant sensibility probably began as a tendency *within* Pictorialism. The trend known as 'second-wave' Pictorialism – associated with Steiglitz and Alvin Langdon Coburn – forsook arty-printing techniques and abandoned literary/mythic subjects for an increased focus on modern life and the metropolis. Some of the most astute recognized that what counted as art had changed: among connoisseurs and artists the aesthetic of Whistler gave way to the new painting associated with Henri Matisse, Pablo Picasso, and the Italian Futurist group. In the final issue of *Camera Work*, which appeared in 1917, Stieglitz showcased the work of Paul Strand, which has frequently been seen as marking a shift in photographic paradigms. Strand's pictures exemplify what came to be called photographic 'modernism': his artworks were not predicated on existing approaches to art. Rather, he based his pictures on what he took to be the inherent qualities of photography: he made direct, optically sharp images; often consisting of details taken from everyday subjects. As Strand put it: 'At every turn the attempt is made to turn the camera into a brush, to make the photograph look like a painting, an etching, a charcoal drawing or whatnot, like anything but a photograph'. Strand preferred the 'simple record in the *National Geographic Magazine*' or the 'aerial photographic record' to what he called Pictorialism's 'bastard photographs'. His argument is based on the idea – central

to modernist art, whether in sculpture or photography – of 'truth to materials'. Carving stone so it appeared like flesh or making photographs that looked like drawings was thought inauthentic. If an art of photography was possible, it would have to follow its own independent path, and not imitate painting or etching. Art-photography had to be 'based on inherent qualities' of the 'medium' and work with the 'true laws of photography'. In 1897, Stieglitz had suggested that 'microscopic sharpness is of no pictorial value', but by 1917 he championed Strand's 'brutal directness'. The shift registered here involves the seeming paradox of the picture in the shape of a document.

Later US photo-modernism, identified with Edward Weston and Ansel Adams, followed the path marked out by Strand and the later Stieglitz. These figures practised photography as an independent art based on what Weston called a 'vital new way of seeing'. Painterly subjects and effects were ditched for 'exaggerating details, recording surfaces' in sharply focused prints. This photography was supposed to be free of any purpose other than expressing the imagination, or feelings, of the photo-visionary: it was to be 'autonomous'. But, at the same time, another conception of photography was developing among European avant-garde artists. The category of the avant-garde – originally a military term meaning the 'advanced guard' – when applied to modern art usually encompasses the Futurists, Dadaists, Constructivists, and Surrealists who worked from c. 1910 to c. 1940. These artists sought to challenge the 'autonomy' of art, or, to put it another way, they opposed treating art as a precious activity distinct from everyday life. Often espousing oppositional or revolutionary politics, they wanted their work to have a role in the reconstruction of society. To this end, many avant-gardists abandoned the traditional media of painting and sculpture for practices that allowed them to intervene directly in modern life: some took to advertising and product design, or political propaganda and mass media work. The design of posters, books, magazines, and exhibitions played an important role in this activity. Arguably, the avant-garde achieved its greatest

triumphs in photography, which was cheap to produce and could be integrated with these new mass forms of communication.

If these artists envisaged a new role for art on the basis of photography, they also reinvented the photographic image. The conception of photography that emerged is sometimes called the 'New Vision'. Writing in 1929, the critic Werner Gräff argued that photographs should not be based on 'aesthetic or artistic rules' from 'bygone eras of painting'. Good photographs, he claimed, often ran 'contrary to the "rules of art"'. Gräff's point chimes with the turn against Pictorialism and 19th-century conceptions that we have already seen. Like Strand and his American successors, the New Vision is a form of modernism interested in the new medium and concerned to elaborate a poetics of technology. To this effect, avant-gardists consciously embraced the possibilities offered by camera and enlarger, producing effects that would previously have been dismissed as unintelligible: close-ups and details; frozen action; double exposure; photograms (images made by exposing objects directly onto sensitized paper without a camera); photomontage (pictures made by pasting together fragments from other photographs and then rephotographing the whole); unusual and extreme angles. Avant-garde artists explored new subjects, but also new ways of representing them. Their models were no longer drawn from paintings, but photojournalism or scientific and technical documents.

With the avant-garde photography enters the standard histories of art; as I have noted, photography can be viewed as the exemplary avant-garde medium. A few of the individuals who appear in art history books conform to the assumed art-historical model of the painter who turned against art for social intervention: John Heartfield, the ex-Dadaist, went on to make photomontages for the German Communist Party; Lazlo Moholy-Nagy included photography prominently among his experiments with light. In the USSR, Alexandr Rodchenko worked with photography in design and photojournalism (while continuing to produce more

Dans toute
sa
force

Photos
GERMAINE
KRULL

La Tour. Clocher des ondes. Sa monstrueuse insurgence a surpris et lassé. Maintenant, à trois cents mètres du sol, les amoureux y donnent des rendez-vous aux oiseaux. Et les poètes, du douanier Rousseau à Jean Cocteau, prétendent que les beaux soirs de printemps, des fées jouent au toboggan sur ses élytres. La Tour demeure l'ultime symbole des temps nouveaux. En quittant New-York et ses palais couronnés de fumées, c'est la Tour Eiffel, toilée aérienne, que Lindbergh visait, pour atteindre Paris, au cœur sentimental du monde.

Elle a les pieds dans la Seine qui, jusqu'à Rouen, même défriche les remorqueurs la France calculée en années. Il manquait à cette géante une chevelure d'étoiles: on la lui a donnée. L'indomptée inscrit maintenant son progrès lumineux sur l'échine nocturne de la Tour.

FLORENT FELS.

Poutres, poutrelles, rivets sont ici comme le vers, les mots et la rime. On ne pense plus à la merveille mécanique, au labeur, à la forge, à la mine. On oublie l'ingénieur, l'ouvrier, le manœuvre, pour ne songer qu'au poète massif, incomparable : RIFFEL.

L'ascenseur, la roue qui entraîne quelques boucles jusqu'à ras des ciseaux, change soudain jusqu'à cette naturel élément. (A gauche.)

En haut, il semble que l'on se déroule en peu des routillonnées serracées. On glisse en pensée toute long, le long de la Tour, jusqu'à la pointe de sa sœur d'ombre qui gît comme l'aiguille d'un cadran solaire. (A droite.)

11. Germaine Krull, 'Dans toute sa force', from *VU*, 1928

conventional artworks); El Lissitsky and Gustav Klucis used photographs in exhibition and poster design (though the former did continue to paint). But many of the other key figures typically characterized as members of the photographic avant-garde were not artists in the first place. August Sander was a portrait photographer; Karl Blossfeldt an art teacher who photographed plants as models for his drawing classes; and Germaine Krull was a photojournalist. In many ways, the idea of avant-garde photography is an invented category and the central figure in that production is, undoubtedly, Walter Benjamin. In his pioneering 'Small History of Photography' (1931), Benjamin included Sander, Blossfeldt, and Krull, along with Atget and others, as photographers allied to a new social vision. It was, undoubtedly, part of their attraction for him that these figures were not 'artists'; he was interested in finding the points of critical perception in everyday life. But many subsequent historians have relied on his text to generate an extended category of the photographic avant-garde. There are some shared values and practices in this work, but the idea of the avant-garde, as commonly framed, is a rag-bag category that proves difficult to separate from a range of other social practices.

Street photography

Alongside this avant-garde project, and in many ways inseparable from it, a new documentary vision took root: this practice has sometimes been labelled 'street photography'. This was work in the 'documentary style', dedicated to recording the popular life of the streets – particularly in working-class and immigrant communities – and which was largely made at the photographers' own instigation. A much attenuated list of photographers working in this mode would include: Henri Cartier-Bresson, André Kertész, Brassaï, Walker Evans, Lisette Model, those associated with the US Photo League (Walter Rosenblum, Sid Grossman, Aaron Siskind, Helen Levitt), Bill Brandt, Willy Ronis, and Robert Doisneau.

It is extremely difficult to distinguish this practice from wider

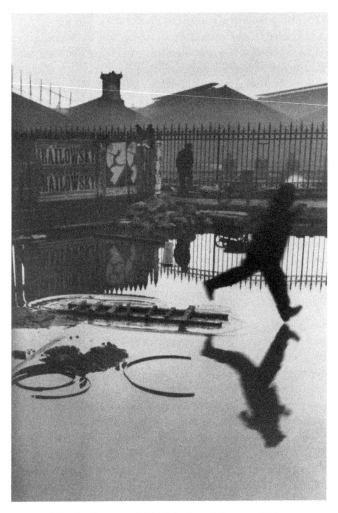

12. Henri Cartier-Bresson, *Behind the Gare St Lazare*, 1932

documentary trends. The categories shade into each other and frequently change places: photographs by street photographers appear in the press or other commercial arenas and documentary work is often exhibited in art galleries. (Brassaï, for instance, was associated with the Surrealists and Evans's dandyish vision set him somewhat askance to documentary.) Nevertheless, it is possible to identify a kind of project in this work that is not quite the same as documentary; this largely centres on street photographers' critical self-direction. By and large, the photographers working in this mode tended to avoid the two key themes of documentary – war reportage and social investigation – though, in the case of the latter category, street photography is characteristically rooted in working-class spaces, while the Photo League's 'Harlem Document' and Evans's FSA work are clearly types of social investigation.

This subset of documentary work offers a strange intermediate zone between art and commercial culture; it is one of those places where clear distinctions between high and low art, or elite and popular culture, dissolve. It is not even possible to say that the purposeless or anti-instrumental character of this work is what defines it as 'art', because images by these photographers frequently appeared in commercial publications. Yet, operating in this cross-over space, photographers created a critical form with a mass audience. Probably the best way to view this work is to say that these photographers worked at their own systematic projects documenting popular life. Particular images could be extracted from these projects and published in diverse contexts, but the archives, and the vision, are not reducible to these commercial outlets. The key form of street photography was the authored photographic book: *Paris de nuit* (Brassaï, 1933), *The English at Home* (Bill Brandt, 1936), *American Photographs* (Walker Evans, 1938), *The Decisive Moment* (Henri Cartier-Bresson, 1952), *Instantanés de Paris* (Robert Doisneau, 1955), *Belleville Ménilmontant* (Willy Ronis, 1954).

This vision is often identified with Cartier-Bresson's concept of 'the

decisive moment' – defined as the precise point at which contingent details aligned to create a perfect compositional arrangement. However, this notion may be too conventionally artistic to characterize street photography. It makes more sense, I think, to view this work as self-consciously artless art. Street photography was largely a practice of the political left: a vision that sought to articulate popular values in opposition to official culture. To this effect, photographers sought out the everyday, the ordinary, and the commonplace; they were attracted to the humour and popular traditions of their subjects. They focused on popular entertainment, life on the street or in the bar, café, or public house. They also employed a style that claimed not to be one – documentary.

One of the key factors that changed in post-war photography was this point of popular identification. Some photographers continued to work in the populist mould (particularly in France), but as the full force of post-war reconstruction (the commercial reshaping of consciousness and everyday life) became manifest, it proved increasingly difficult to view popular life as a force inimical to capitalist social relations. Continued attachment to a populist documentary vision began to look sentimental and nostalgic. In this new context, especially in the USA where the full force of these processes ripped through society, some photographers came to view the popular life of the street, not as a life untainted by middle-class values, but as representing a particularly supine embrace of Mammon's values. Photographers shifted from adopting the viewpoint of popular life to a detached and caustic perspective on it.

Initially, at least, this dislocation from popular pleasures produced highly critical representations of the emerging post-war society. The books produced by Robert Frank (*The Americans*, published in 1958) and William Klein (*Life is Good and Good for You in New York: Trance Witness Revels*, from 1956) give vent to an alienated vision of America: as a world of conformity, banality, and latent violence. In the period of the Cold War, these images did not go down well with the critics: one described Frank's book as 'marred by

spite, bitterness and narrow prejudices'; another suggested it amounted to 'an attack on the United States'. Increasingly, however, the street tradition went through a mutation, shedding the vestiges of social vision for more private concerns. No doubt, the McCarthyite witch-hunt of 'subversives' (which at one point turned its attention to the Photo League) accelerated this process. Some, like Aaron Siskind, turned away from their former commitments to a type of photography that aped abstract painting; others produced a modified, formally stylized version of street photography that foregrounded the perception of the photographer.

Medium specificity

The central figure in this transformation was perhaps best known for his work as a curator and critic rather than his pictures. John Szarkowski was appointed curator of photographs at the Museum of Modern Art in New York in 1962. From this powerful institutional base, he produced a highly influential account of photography, which jettisoned the social vision of documentary.

13. Lee Friedlander, *Hillcrest*, New York, 1970

This emphasis is apparent in Szarkowski's important 1967 show *New Documents*, which presented the photographs of Diane Arbus, Lee Friedlander, and Garry Winogrand as inheritors of the documentary tradition.

He claimed this work represented a reinvention of documentary. The 1930s documentary, he argued, had been associated with projects of social reform and political change. Szarkowski now claimed that photographers wanted simply to explore the potential of their medium, or express themselves through it. If these were documents, they were documents turned inwards.

Szarkowski presented an account of photography shaped by the modernist idea of 'medium specificity'. We have already seen one version of this advanced by Paul Strand. This argument, which has long roots and many variants, suggests that significant art results from the focus on those characteristics inherent in a medium. The notion of medium specificity tends to emphasize the means of depiction over what is depicted. By concentrating on the specific features of painting, sculpture, or photography, artists push the boundaries of their art and create new aesthetic or expressive effects. Often, this conception involves foregrounding those features of a medium that distinguish it from other art forms. As we will see, Szarkowski argues that photography is not a literary form (it does not involve storytelling). Artists in the post-war modernist tradition, working in many different arts, explored the parameters of their medium by stripping away, what they saw as, extraneous references and accumulated traditions. For painters, this idea meant testing effects that could be produced by making marks on a flat surface. In pursuing medium-specific ways of working, the visual arts tended to abstraction or 'purification'. However, unlike paintings, photographs are tied to external appearances. As such, medium specificity in photography could not follow in the path of abstraction; instead it entailed emphasizing what was unique about a camera image.

In the catalogue accompanying the exhibition *The Photographer's Eye* (MoMA 1964), Szarkowski insisted that a proper account of photography had to encompass, as 'intimately interdependent aspects of a single history', both art-photography and the 'functional' uses of the medium. He was to make 'vernacular photography' central to art-photography. The term 'vernacular' is employed, typically with regard to architecture or articles of use, to describe anonymous forms that come into being over a protracted period. In contrast to 'architecture', associated with named makers and conscious stylistic trends, vernacular buildings are lowly, everyday, and traditional. A barn is often a vernacular building, a bank rarely is. Vernacular photographs include amateur snapshots of family high days and holidays, or the types of functional document found in specialist archives: police images, technical records, and so on. Strand's examples from the *National Geographic* or aerial surveys convey the point well. Szarkowski believed that vernacular photographs made by 'journeymen', 'hobbyists', technical document-makers, and so forth revealed what was essential about photographic seeing. According to him, making photographic pictures did not entail imitating painting, but following through the implications of an apparatus. The photographers he championed – Winogrand, Friedlander, Arbus, William Eggleston, and others – produced autonomous pictures rooted in vernacular conventions.

The Photographer's Eye isolates five properties that Szarkowski felt characterized the medium: 'The Thing Itself'; 'The Detail'; 'The Frame'; 'Time'; and 'Vantage Point'. The issue, for him, was not to follow established conventions of art, but to make choices based on the way the photographic apparatus transformed an existing scene into a unique type of picture. For instance, in discussing the frame, Szarkowski wrote:

> The edges of the picture were seldom neat. Parts of figures or buildings or features of landscape were truncated, leaving a shape

belonging not to the subject, but (if the picture was a good one) to the balance, the propriety, of the image.

In this sense, photographs isolate and focus attention on 'details'. A number of these categories will crop up, in various guises, later in this book, and I am not going to develop them here. What needs to be observed, is that for Szarkowski features inherent in photography are most often apparent in vernacular images: lopped-off heads abound in the family album. But, he believed, whereas 19th-century art-photography and Pictorialism repressed these features, the best photo-art consciously built on these characteristics. This is to say, the implications of contemporary art-photographers were latent in the medium from the outset. 'Like an organism', he claimed, 'photography was born whole'. Art in photography is made from details and fragments; unusual vantage points; effects that emphasize odd things that seem to sprout from the tops of heads; and so on. Development in art-photography, according to him, is driven by the medium becoming self-conscious. Sometimes photographers appear to be the bearers of this unfolding photographic consciousness, but the implications were always present in the medium itself. What makes some photographers special, in Szarkowski's view, is the rigour with which they pursue the unique characteristics of photography.

There is a great deal to be learned from this account. Nevertheless, its transhistorical emphasis is deeply problematic. It is difficult to imagine how photography, as perhaps the privileged medium of 20th-century communication, can be dealt with as a singular 'medium'. The practical use of photographic documents, or their role in generating social and sexual fantasies, have much greater weight than art-photography, but Szarkowski glosses over *these* everyday practices. Szarkowski tends to strip photographs of their specific context and use in order to tell a single story of art. It is worth noting that his tenure at MoMA coincided with the revaluation of photography in the art museum. This is the period when photographs entered the art market in a significant way.

Szarkowski's particular version of 'modernism' provides one ingenious way of stabilizing this category. As photographer-theorist Allan Sekula suggested, his approach:

> neutralizes and renders equivalent, it is a universalizing system of reading. Only formalism can unite all the photographs in the world in one room, mount them behind glass, and *sell* them.

The everyday and the mass media

At the same time that this later generation of street photographers championed by Szarkowski was busy exploring the particular kind of image that could be produced with a camera, artists began using photographs in an altogether different way. Many of them didn't give a damn about which characteristics were peculiar to the medium; they cared even less about a convoluted art-photography.

By the 1960s, the discourse and the practice of medium specificity seemed played out in adventurous art (it persisted a while longer in art-photography); the art produced according to this conception was increasingly formulaic and empty, and rather than acting as an impetus to critical thought, the ideas had become a barrier to it. In any case, this version of modernism was never totally hegemonic: some artists had continued to produce representations or work in deliberately hybrid and 'impure' forms. In this vein, it made sense that some artists became interested in exploring the effects and forms of mass photography. For instance, Pop artist Andy Warhol made paintings by applying found photographs to canvas with the silk screen print technique. Typically, Warhol repeated the same image four, six, eight times, sometimes more, building up a grid of photographic images that displayed minor variations. Sometimes he varied the colour; sometimes the resulting picture consisted of nothing but (almost) identical black and white images. Warhol, like many of the artists who followed him, was interested in the banality of photography, rather than its potential for making nuanced and

complicated pictures. The range of his subjects – disasters, suicides, race riots, and celebrities – has the feel of a compendium of the mass media at a particular moment. Photography really attained its current status in contemporary art when artists ditched any attempt to produce a unique, medium-specific art of photography and began to trade on its actual uses, in particular on the photograph as a seemingly literal carrier of information. What came to matter to this generation of artists was the role photography played in everyday life; its ubiquity and its ability to record events, people, and things; its role in the increasingly prominent consciousness industries. Describing the books he made with photographs, the artist Ed Ruscha said:

> Above all, the photographs I use are not 'arty' in any sense of the word. I think photography is dead as a fine art; its only place is in the commercial world, for technical or information purposes. I don't mean cinema photography, but still photography, that is limited edition, individual, hand-processed photographs. Mine are simply reproductions of photographs. This is not a book to house a collection of art photographs – they are technical data like industrial photography. To me, they are nothing more than snapshots.

This does not mean that what artists did with photographs at this time was any less complex or ambitious than medium-specific practice (Ruscha's work is a case in point), but what increasingly mattered was photography's ordinariness and utility.

Photography has been able to assume a prominent role in contemporary art because its various forms and uses mesh with modern culture itself. From the 1960s, artists became particularly engaged with everyday life under late capitalism; the very instability and reach of photography came to occupy a central place in their panoply of techniques and strategies. In the first instance, those working in what has been called the 'expanded field' of art (the exploration of new materials and possibilities beyond

traditional definitions of painting and sculpture) adopted the photographic document for its simple power of recording. In Conceptual art, and the forms that spiralled out of it (performance or body art, land art), photography provided a useful tool for presenting information, or for displaying works that were time-based, ephemeral, or inaccessible. A remote earthwork or journey, a temporary installation, an action or event could all be recorded and represented as photo-documents. Bernd and Hilla Becher's archive of disappearing industrial forms begun in the 1960s – mine heads, cooling towers, blast furnaces – provides an exemplary instance. In these works, the photograph functions as a trace of its subject: the form is plain and direct. Banality can, of course, be employed as a device for stretching the viewer's attention – for renewing art in a distracted age; similarly, some artists used the plain document as a counter-weight to the spectacular values of the mass media.

In contemporary art, the photographic image is used to examine a wide range of identities, fantasies, memories, places, and so on. Nevertheless, two main tendencies are discernible: on the one hand, artists and photographers have continued to use the rhetoric of the document, adopted during the 1960s and 1970s, to explore everyday life; and, on the other, they have investigated the role of photography in mass culture, usually employing staged images. These concerns are closely related, because everyday life in late capitalism is closely entwined with mass imagery. Neither branch is very interested in the high-flown values traditionally associated with art; both versions pay less attention to complexities of form than to photography's uses. (Though, this investigation of use can lead to new ideas about form.)

The continued exploration of everyday life in photography usually retains the rhetoric of the document to reveal the overlooked and the ordinary. The focus here is on those things, activities, or places that usually draw little attention: say, a simple gesture, the space under a bed, the debris of a meal, or a section of carpet. Sometimes

these things attain a strange beauty, at others their very ordinariness is stressed; in some instances, the seemingly trivial details of life take on a transcendent or quasi-spiritual quality, in others the photographer keeps things down-to-earth. At least since the New Topographic work of the 1970s, which rejected traditional romantic visions of nature for a focus on the 'man-altered landscape', photographers have been preoccupied with depicting ordinary places – usually those that have gone without notice or been disparaged: trailer parks, suburban areas, the detritus gathered under a roadway bridge, or scraps of urban waste land. One variant involves photographs of poignant spaces, those empty and derelict sites that have been associated with repression, torture, and state power – notorious prison camps, bombed-out military installations, nuclear bunkers, and the rest. This work trades on the 'banality of evil' – the very ordinariness of these sites of modern horror, which display minimal traces of their previous function – but also the banality of the images.

Medium-specific practice in photography drew its vernacular models from photojournalism and amateur snapshots, but this entails a highly restricted idea of the photographic medium. Advertising, fashion, porn, and so on typically all fall outside this vision. In contrast, much contemporary photographic art has been preoccupied with these commercial forms; this entails a very different sense of photography, which includes attention to ideology and mass-produced fantasy. Since the 1970s, many artists and photographers have made images that interrogate photography's role in these wider social forms and their effects. Often this investigation entails recourse to 'impure' photographic forms that mix text or recorded sound with images, combine genres, or use images appropriated from the mass media. Predominantly, these photographers have abandoned the 'straight aesthetic' of the street photographer for an art of staging or construction, which involves setting up events or performing for the camera. Work of this type allows photographers to explore complex scenarios or attitudes in a situation under their control.

14. **Cindy Sherman,** *Untitled Film Still No. 37,* **1979**

Cindy Sherman's pictures, to take one prominent example, employ
the conventions of cinema, particularly melodrama, to unmask
some powerful ideologies of femininity as appearance.

In the series *Untitled Film Stills*, begun in 1977, Sherman features
in each picture in a different guise, pose, and scenario. These
photographs are in some sense self-portraits, but they are
paradoxical ones. Much of the critical effect of Sherman's *Film*

Stills results from her presence in these staged scenes, because in each picture she appears as a different character. Feminists have suggested there is no real Sherman to be found beneath these pictures: the images of femininity are all there is. Sherman's staging of the conventional images of women brings into view the way that gender, in this case femininity, is partly a product of the mass media. The idea that there are a range of 'styles', 'images', or 'looks' that we can adopt is now prevalent enough: a brief list of the images of women she has created include the dumb blonde, the bad girl, and the femme fatale. The identities are made, in part at least, through images: femininity is inseparable from the formal conventions of the picture, which include lighting, pose, composition and pictorial style, and bodily comportment.

Increasingly, these issues and approaches have tended to converge and cross over. Rather than documenting everyday life, some have taken to reconstructing these scenes. Jeff Wall, for instance, creates elaborately constructed scenarios using the full panoply of film production techniques to produce pictures of ordinary life: a street fight, a sleepless night, and so on. For Wall, this technique enables a complex exploration of social situations without the voyeurism implicit in much of the street tradition. Whereas a number of German photographers, prominent for the last 20 years, have pictured everyday life in high-colour images on the scale of museum art. In contrast, others have continued to work in a form derived from documentary. Allan Sekula's monumental *Fish Story* – one of the richest presentations of the modern world in any medium – represents a 'documentary' practice informed by the critique of this mode. Indeed, Sekula played a key role in developing this critical understanding of documentary. In a related vein, one recent large exhibition drew together a range of artists who all base their work on the contemporary news media. The examples could be multiplied. Photography occupies a pivotal location in contemporary art, because its diverse forms and seeming proximity to reality has enabled it to become an important tool for exploring modern culture and its values.

Chapter 4
What is a photograph?

In the two preceding chapters I examined some structuring distinctions shaping our experience of photographs: principally, the opposition between documents and pictures; documentary and art. In this chapter, and the one that follows, I want to go over some of the same ground, but where Chapters 2 and 3 treated this problem historically, here the emphasis will be more theoretical, but also more experiential. This will involve some attention to the invention of photography.

Proof

In the film *Proof* the central character – Martin, who is blind – takes photographs of things in order to test their existence. The film centres on the relationship between Martin and his housekeeper, Celia: he withholds the love and affection she craves; Celia responds with small acts of sadism – positioning objects so he will stumble over them, enticing away his guide-dog, continually watching him, and, eventually, seducing his one friend. The malice and humour evident in *Proof* revolve around Martin's rejection of Celia and her minor cruelties, but underpinning all this is the theme of trust, and photography is central to this issue. Martin does not trust the sighted, because he is unable to verify their descriptions. As far as he is concerned, sighted people are able to deceive him with false, or inaccurate, accounts of appearances. He believes his mother was

embarrassed by him and suspects that she took her revenge by describing things that were not there (he even claims that she faked her own death to escape from him). Martin photographs things and events, subsequently he has an independent witness describe the images – firstly Celia, and then his friend Andy. In so far as these people did not witness the things represented, but corroborate what he knows of events and what people have said to him, he is able to verify the situations he experienced. He is, of course, also testing the describers of the pictures. (As the plot unfolds, this becomes complicated, because Andy and Celia increasingly wish to keep secrets from Martin.) Photography performs this role in *Proof* because it is assumed to be an automatic and mechanical recording technology, which accurately reproduces the appearance of things. In this film, the camera is presented as an objective and independent witness, operating independently of the photographer and his desires (he can't even see what it sees). Eventually, through the medium of an old black-and-white image, Martin discovers what he took to be a key example of his mother's descriptive deceit was, in fact, an accurate account.

Photographs might be truthful, *Proof* suggests, but the descriptions of pictures are not at all reliable. The film thus entwines photography with trust, anxiety, and human relationships (it is clear that this scenario is a metaphor for film-making itself, and perhaps for the activity of the critic), but the idea that 'the camera never lies' saturates our culture. Common sense perceives the photograph as a 'transparent' or 'unmediated' copy of reality. This conception of photography as an objective recording technology can be found in the news media, which takes as one of its founding ideologies the idea that the apparatus presents an impartial record of events and is equally present in the family album, which employs photographs to memorialize key (if selective) rites of passage. We have come to distrust advertising, but even here we doubt less the images than the motivations of the persons who put them into place.

Pornography (one of the mainstays of photographic imagery in

Western society) similarly relies on the strange realism of the camera. Despite the staged, fantasy scenarios, dodgy sets, and carefully arranged lighting, these pictures appear to offer their viewer direct access to a body and its organs. In pornography, like so many other forms of photography, the viewer is induced to look through the surface of the paper or the screen and imagine themselves in the full presence of another person: we might recognize the fiction, but nevertheless Much of the power of photography derives from this kind of compelling illusion. What needs accounting for is the peculiar form of the photographic image, which appears not to be an image at all; rather, it seems like a direct re-presentation of lived reality. Photography's effects, for good or ill, derive from this constitutive condition.

The idea that photography represents an unmediated, faithful re-presentation of things has been hanging around the medium for a long time. As we have seen, some of the earliest conceptions of the process were based on this sense of automatic recording. As Talbot put it, in photography: 'it is not the artist who makes the picture, but the picture which makes ITSELF'. Because the camera was thought to require only minimal human intervention to generate images, the resulting pictures were deemed impartial and free of subjective intention. Art-photographers worked very hard to wrench their images away from this common-sense view that photography produced a literal copy of reality, which required little or no intervention from the 'operator'.

In 1945, the film critic André Bazin provided a classic statement of this common-sense conception in his essay 'The Ontology of the Photographic Image'. Bazin claimed that photography (and cinema) satisfied the basic human desire for illusion and realism. For him, the important point was that the camera was a 'nonliving agent'. He wrote:

> [f]or the first time an image of the world is formed automatically, without the creative intervention of man. The personality of the

photographer enters into the proceedings only in his selection of the object to be photographed and by way of the purpose he has in mind. Although the final result may reflect something of his personality, this does not play the same role as is played by that of the painter.

In Bazin's account, the absence, or minimal involvement, of the photographer resulted in a picture independent of subjective volition. This 'impassive mechanical process' conferred on photography 'a quality of credibility absent from all other picture-making'. Bazin thought photographs to be objective, faithful copies of things. Looking at a photograph, he suggested, we are 'forced to accept as real the existence of the object reproduced'. He claimed:

> [t]he photographic image is the object itself, the object freed from the conditions of space and time that govern it. No matter how fuzzy, distorted, or discoloured, no matter how lacking in documentary value the image might be, it shares, by virtue of the very process of its becoming, the being of the model which it is the reproduction; it *is* the model.

The photograph and the object it represents, according to Bazin, share a 'common being, after the fashion of a fingerprint'. (Despite all this, he ended by claiming '[o]n the other hand, of course, cinema is also a language'.) To begin to understand what is claimed for photography here, we need to know something of the 'very process of its becoming' that Bazin spoke of.

Invention

The story of photography's invention is complex and is surrounded with a great deal of mythology. All I want to do in this chapter is give some sense of the way the basic features of the process shape our experience of photographic images. Photography did not spring forth from nowhere: in the expanding capitalist culture of

the late 18th and early 19th centuries, some people were on the look-out for cheap mechanical means for producing images, both portraits for the new middle class and the wide range of visual documents required by the new society. Some existing reproductive techniques preceded new uses; others were devised to meet the emerging desires.

Towards the end of the 18th century, a Silhouette apparatus was introduced in France: the sitter, illuminated from behind with a candle, was placed behind an upright sheet of paper, the artist could then simply draw around the outline, and fill it in. In 1786, the Frenchman Gilles-Louis Chrétien introduced the *Physionotrace*, which could be used to speed up the production of portraits: one sitting resulted in twelve engravings. The *Physionotrace* was based on the pantograph (a device consisting of a series of jointed rods, which reproduces whatever is traced with a stylus at one end on a different scale at the other). The sitter was placed before a screen and traced resulting in a reduced outline that could then be embellished by the artist. In Britain, methods for producing mechanical paintings were devised, in the later 18th century by Matthew Boulton and Joseph Booth (the latter made a direct analogy between his apparatus and the Lancashire cotton factories); while James Watt developed a machine for 'the art of multiplying statues by machinery'. In the early 19th century, Charles Babbage, the mathematician and pioneer of computing, also recorded the existence of drawing machines: he described two exhibited automata – the 'Prosopographus' and the 'Corinthian Maid' – that could, by means of a pantograph attached to a drawing instrument (the camera lucida), execute the likeness of sitters.

There was clearly an interest in reproductive technologies at this time. Photography was related to these devices as a technique for mechanizing drawing, but it was also distinct from them in significant ways. Joel Snyder has convincingly argued that photography emerged experimentally from the conjuncture of three factors: i) concerns with amateur drawing and/or techniques for

reproducing printed matter; ii) light-sensitive materials; iii) the use of the camera obscura (this is discussed below, but basically it involved a dark room or box that enabled a cast image of external objects to become visible). Until these distinct factors came into alignment in the work of Louis-Jacques-Mandé Daguerre, Talbot, and others, photography could not be imagined.

Photography made its first public appearance in 1839 when its discovery was announced by the scientist and French Republican politician François Arago at the Institut de France. In his statement, Arago attributed the discovery to Daguerre: in fact, Daguerre had worked with, and built on, the discoveries of Joseph Nicéphore Niépce, who died before the announcement had been made. Arago's public pronouncement brought forward a series of counter-claims from others who suggested they had invented photography, including Hippolyte Bayard in France and Talbot in England; perhaps, most strikingly, it has subsequently been understood that Antoine Hércules Romauld Florence, a Frenchman who settled in Brazil in 1824, independently discovered photography and may have been the first to use the word itself (he used the process to print labels and ornamental patterns). All these men had worked at the problem of how to produce images with light and chemical substances, and they all came up with distinct solutions. On hearing about photography in 1839, the eminent British scientist Sir John Herschel worked out how to do it for himself in a few months. All in all, it has been suggested that as many as 24 people claimed to have originated photography. The fact that so many researchers had been working on the problem suggests that they were responding to a felt need. Society sets itself precisely those problems that it can solve.

The conditions for photography's emergence (in the light of so many competing claims, the words 'invention' or 'discovery' seem a little overblown) were earlier experiments with light-sensitive chemicals and the prior use of the camera obscura. When, during the 1820s and 1830s, these elements were combined, they produced

a remarkably powerful image system. In the course of the 18th century, Johann Heinrich Schulze, Carl Wilhelm Scheele, and Jean Senebier had all observed that silver salts darkened on exposure to light. While Schulze's experiments were confined to his notebook, this phenomenon became known through the publications of the other two men.

In 1802, Thomas Wedgwood and Humphrey Davy published a paper in the *Journal of the Royal Institution* giving details of how to copy silhouettes or drawings on paper, or pale leather, treated with silver nitrate. They attempted to copy paintings on glass by projecting light through them onto a flat surface treated with this chemical solution. The silver nitrate used by Wedgwood and Davy, however, was insufficiently sensitive and they failed in their aim; they had more success with silhouettes placed in direct contact with the treated paper or leather. (This kind of photographic image produced, without a camera, by placing an object directly on to light-sensitive material and exposing it, is typically called 'contact printing'; the images themselves are referred to as 'contact prints'.) On exposure to light, the area not obscured by the paper darkened. The result was an inverted image of the original: the area screened by the cut-out profile remained white, while the general ground of the image turned black. There is some doubt about these early experiments, it is probable, though, that Wedgwood and Davy did produce images, but that they were unable to stabilize, or 'fix', them. Gradually the light areas darkened, and then the whole thing faded away. As they said in their paper: 'nothing but a method of preventing the unshaded part of the delineation from being coloured by exposure to the day is wanting, to render the process as useful as it is elegant'.

None of these early chemical experimenters employed a camera obscura (or other drawing apparatus) in conjunction with their experiments on silver salts. The principle of the camera obscura (literally 'dark room') has been understood since antiquity.

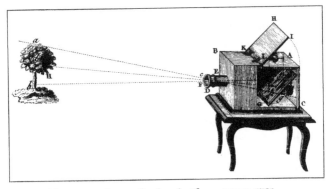

15. Portable camera obscura for drawing from nature, 1781

It was observed that when light passed through a small aperture in a shutter covering the window to a dark room, a cast, inverted image of the external view appeared on the opposite wall. The Arab scholar Alhazen commented on the camera obscura in the 11th century, and it was discussed by a number of other writers before Giovanni Battista della Porta made the apparatus familiar to Renaissance artists in 1558. At some point in the 16th century, a lens replaced the simple aperture; because the lens gathered light across its surface and focused it at one point, it sharpened and intensified the cast image. At this stage the camera obscura was still literally a room; in the century that followed small versions began to appear in which a lens was attached to a box or tube. Fitting an internal mirror into these small devices allowed the cast image to be turned the right way up. When a ground glass screen was substituted for the plane onto which the image was cast, the artist could trace the projected view. The camera obscura cast a perspective image of whatever appeared in front of it, but this image had to be recorded by a human hand employing a drawing pencil; as such, it was more suitable for depicting static objects than dynamic ones. For unchanging views, however, the camera obscura allowed perspectively accurate drawings to be made with much less time and trouble than working with hand and eye alone.

Many artists – Canaletto prominent among them; probably Jan Vermeer too – made use of the camera obscura. Talbot felt that the 'fairy pictures' viewed on the ground glass of this apparatus were incredibly beautiful, but, unless it was used by a skilled draughtsman, the tracing that resulted was 'a mere souvenir of the scene'. Consequently, he set about finding a way to fix this image. The modern photographic camera is, in essentials, a camera obscura: light passes through a lens onto a plane, but, whereas the traditional arrangement focused light on a glass screen, in the photographic camera light is made to converge on a chemically sensitized plate or film. In modern cameras, a diaphragm, which can be opened and closed, has been introduced into the lens, enabling the photographer to increase or decrease the amount of light that falls on plate or film; a shutter has also been added between the lens and the film in order to control the length of exposure.

There was nothing inevitable about the conjunction of the camera obscura and light-sensitive chemicals. In fact, both key components of the photograph had been known for a century before they were united. Furthermore, while the early photographic experimenters all created images using chemical substances sensitive to light, not all of them combined these materials with the camera obscura. Sometimes Talbot employed a camera obscura; at others he made contact prints like those attributed to Wedgwood and Davy. In the period between 1816 and 1828, Niépce worked on a printing process using light-sensitive substances. In the main, he was concerned to copy existing pictures (he was looking for a reproductive technique that would replace lithography), but around 1826 he did succeed, after several hours' exposure, in making an image from a bedroom window in a camera obscura (the result is often regarded as the oldest surviving photograph).

Niépce experimented with a range of plates, including silver, pewter, and silver-plated copper. He also investigated a range of chemicals such as silver chlorine and iodine, but he had most

success with bitumen of Judea, which becomes insoluble when exposed to light. In order to copy prints or drawings, he first oiled, or varnished, the original, making it transparent; he then applied this image to a plate treated with bitumen of Judea and subjected it to light. Where the dark areas of the image blocked light from coming into contact with the treated area, the bitumen of Judea remained soft and could subsequently be washed away with lavender oil. He then treated this plate as one would treat an etching plate: that is to say, the plate was immersed in acid, creating an indentation or furrow where the metal was exposed, whereas those portions of the plate that had been obscured by the hardened bitumen of Judea were left untouched. After this acid biting the plate was cleaned back to the metal surface, leaving the areas that had been uncovered recessed and the section that had been protected from the acid standing proud. At this point, Niépce had a printing plate: when ink was applied and wiped clean, the recessed areas retained a residue of printers' ink, whereas any area that had not been touched by the acid would not. When a sheet of paper was applied to the plate under pressure, the result was a (reversed) printed facsimile in ink of the original print or drawing.

In 1829, Niépce entered into collaboration with artist, set painter, and showman Daguerre, who had also been experimenting with camera obscura images. When Niépce died in 1833, Daguerre continued to experiment with chemically produced images. He concentrated on what has come to be known as the 'latent image': when light-sensitive materials are exposed to light they register an image, which can remain latent or invisible. However, this latent image can be boosted and brought out by subsequent chemical treatment; in modern photography we say it can be 'developed'. Before the principle of the latent image was understood, the production of photographic images required very long exposures to light. But the latent image treated with accelerating agents or 'developers', allowed much shorter exposure times. Niépce had already experimented with latency, treating his plates after

exposure with iodine, but Daguerre was able to improve the process considerably with mercury vapour. He produced his images – known as daguerreotypes – by treating silver-plated copper sheet, which had been highly polished, with iodine fumes.

The resulting chemical reaction created a deposit of light-sensitive silver iodide on the plate. This plate was then exposed for four or five minutes in a camera obscura. After exposure, Daguerre treated the exposed plate with mercury vapour to enhance the latent image: the result was a highly detailed photograph. He was able to stabilize this process with a common salt solution which prevented any further reaction to light. Before 1851, the daguerreotype, partly because of patent restrictions on other processes and partly due to its remarkable detail, dominated European photography. It did, though, have some significant drawbacks: the image was very fragile and contact with the surface easily rubbed it from the plate, so daguerreotypes were kept in protective velvet and glass cases. The key problem, however, was that each image was unique. The

16. Daguerre, *Still Life*, 1837

daguerreotype did not really solve the problem of reproduction or the need for multiple images.

Working in England, Talbot came up with a different process, which, while it did not have the high resolution of Daguerre's technique, did enable him to produce multiple copies. In many ways, subsequent photographic processes derive from Talbot's conception of photography. Working on his process from 1833, he began making cameraless contact prints by coating paper with successive treatments of salt and silver nitrate, which reacted to produce light-sensitive silver chloride. He then placed flat, transparent or translucent objects (leaves, plants, lace) directly onto the paper and set them in the sun for a period ranging anywhere from 10 to 30 minutes. Once again, where light passed uninhibited through these objects, the paper darkened; where the light was blocked, the paper retained its original colour. Talbot stabilized the image with a strong salt solution which dissolved the residual silver salts. He called these images 'photogenic drawings'.

In February 1835, he realized that the process could be repeated by using this first image as a 'negative', which could subsequently be used to generate a second 'positive' print. (The terms negative and positive were suggested by Herschel, who is usually also credited with coining the term 'photography', which literally means 'light writing'.) Theoretically, this meant that a large number of positive prints could be generated from a single negative and that in these positives the light and dark areas would roughly parallel those in the object depicted. However, at this stage, Talbot's negatives were insufficiently dense to create strong positive images. In 1840, he discovered a second process, which he called the Calotype (from the Greek word *kalos* for beautiful and useful). The Calotype process combined silver nitrate with acetic acid and gallic acid, and produced a latent image after an exposure of a few seconds. Talbot treated the outcome with an accelerating agent (gallic acid), enhancing the latent image, this

resulted in a negative strong enough to allow further copies to be produced.

Throughout the 19th century, improvements to lenses and better chemical solutions significantly reduced exposure times. However, a central problem still faced photographic experimenters: all these processes were monochrome. Black-and-white photographs register levels of luminosity rather than colours. Experiments with coloured photography have a long and intricate history; here I simply want to indicate some basic principles.

Colour photography is rooted in Sir Isaac Newton's demonstration that white light can be split prismatically into a rainbow of component colours (wavelengths of light). Colour photographs have, essentially, been made in one of two ways: on the one hand, are those processes that involve breaking down the image into a number of distinct single colour registrations. In this kind of process, three, or sometimes more, monochrome images (typically, a cyan blue image, a magenta image, and a yellow one) are superimposed, or bonded, to create a multi-colour photograph. Processes of this type are known as 'separation processes'. Photographs in the second category are produced, not by superimposing separate layers, but through chemical reaction. Modern versions of this second technique are based on a principle of 'chromogenesis': that is to say, molecules of coloured dye react with silver salts exposed to light. In one version, different coloured dyes are suspended in layers of emulsion. The coloured layers become active when darkening silver salts react with these dyes; the silver is then bleached out to leave only the specific colour present in that layer of film. In another chromogenic process, coloured dyes are coupled to silver in the developing process. For this reason, chromogenic processes are sometimes called 'colour-coupling processes'. It is notable that in each case, pre-set colours are activated by light: colour photographs *approximate* the colours seen in the world, rather than strictly reproducing them.

It should be clear from the preceding descriptions of black and white, as well as colour, processes that photographs occur when light bouncing off objects causes chemical changes in a film or plate. This means that photographs are, in highly significant ways, direct impressions of the things they depict. The chemical bond between light and silver salts, or chromogenic dyes, has important consequences for our understanding of photographs. (At the end of this book, I will come to the question of digital images and how they may depart from the conditions of these 'analogue' forms of photography.)

Signification

These optical-chemical processes make photographs very peculiar images. As we have seen, André Bazin drew the conclusion from photography's 'very process of its becoming' that the image was an unmediated copy, or trace, of the object before the lens. As with any complex field of culture, there is now a range of competing interpretations of what this process means: in this section I am going to outline a powerful argument for photographic realism (disbelief will be suspended for the next chapter).

One influential approach to photography involves recourse to ideas developed by the American Pragmatist philosopher Charles Sanders Peirce, who was active at the end of the 19th century. Peirce was a polymath who wrote on mathematics, religion, logic, and a dozen things besides; he barely mentioned photography, but his work on the typology of signs employed in communication has a direct bearing on photography. Peirce was a pioneer in the study of the role played by signs in the construction of meaning, an intellectual approach to culture called semiology or semiotics. Peirce argued that all communication takes place through the medium of signs, which must always be embodied in some material vehicle, whether a spoken word or a metal road sign. His work in this field is complex, technical, and much debated: Peirce was fond of tabulating all possible permutations – originally identifying 10

combinations for signs (he later extended this to 66 correlations). For our purposes, we can focus on one sign triad that appears in his important essay 'Logic as Semiotic: The Theory of Signs', written between 1897 and c. 1910. In this text, Peirce drew attention to three components of signs: these are often characterized as 'iconic signs', 'indexical signs', and 'symbolic signs', though, strictly speaking, these are not distinct types of sign at all, but features shared by signs.

Iconic signs share some qualitative characteristic with the object they represent; icons, in some way or other, resemble the object they stand for. Peirce drew his example from mathematical formulae, but the example of figurative art may help to illustrate the point. Painting and drawing can convey meaning through visual resemblance between the sign and the object depicted: a drawing of a chair shows a four-legged object, with a seat and a back, in three-dimensional space. While we are unlikely to confuse pencil marks on a sheet of paper with the thing we sit on, a drawing can represent or resemble a chair. Icons continue to operate in this fashion even when the characteristics shared with the object are radically simplified: think, for instance, of the sign 'No Dogs Allowed', which reduces the canine image to a few easily recognizable characteristics and which differs from any actual animal. As Peirce put it, a diagram is an icon 'even though there be no sensuous resemblance between it and its object, but only an analogy between the relations of the parts of each'. One key characteristic of iconic signs, according to Peirce, is that they can operate even in the absence of the object in question: a drawing does not need to depict an actual chair for us to recognize it as an image of a chair.

This is an important point in relation to the second category of signs – indexical signs – which entail some direct relationship to the object at issue. Peirce suggests that while indices do not necessarily resemble the objects they refer to, they bear a causal connection to those objects and would not have the character they do if their

object was absent or did not exist. A footprint, for instance, was caused by the human presence that we take it to signify; a mooing sound calls to mind a particular kind of animal; and, as the proverb has it, 'there is no smoke without fire'. To return to André Bazin's example, a fingerprint is an index of a particular human finger, separate from all others. Because indexical signs are causally linked to their object, they come into being at a definite time and in a particular place, they usually refer to individual cases rather than generic categories. Whereas the sign 'No Dogs Allowed' refers to dogs in general, the excrement on the pavement is an index of an all too particular animal. Indices direct attention to their object; like the index finger, they point. (Because signs need to be embodied in material forms, all signs must have an indexical component.)

Peirce's third category – symbolic signs – conveys meaning by convention and consensus; operating, according to him, 'by virtue of a law'. Red, amber, and green lights, for example, are conventional signs employed to control traffic flows. Symbolic signs play the central role in human communication: as Peirce suggested, words and sentences are conventional signs and, therefore, symbols. Both written and spoken words convey meaning through conventional use and not through any intrinsic relation to their referents.

Many commentators have suggested, on the basis of Peirce's account, that photographs are indexical signs. This is not quite right: his distinctions are meant as abstract categories to help us see how signs work, rather than exclusive types. Any actual sign, photography in this instance, will combine these features. The iconic dimension of photographs ought to be readily apparent, since photographs look like the things they depict; under particular circumstances, photographs also produce symbolic meanings (a photograph of an assassinated political leader carried on a demonstration can symbolize a struggle for justice); and because photographs are the direct result of light bouncing off depicted objects, they bear an indexical relation to the thing pictured. As Peirce put it:

[p]hotographs, especially instantaneous photographs, are very instructive, because we know that they are in certain respects exactly like the objects they represent. But this resemblance is due to the photographs having been produced under such circumstances that they were physically forced to correspond point by point to nature.

In this essay he also claimed the fact that the photograph 'is known to be an effect of radiations from the object renders it an index and highly informative'. What is unusual about photographs, though, is not that they are indices; all signs are indexical of something – speech is an index of a speaker; writing of a hand employing a pen or moving over a keyboard; traffic signs of both a fabricator and an act of planning. What *is* particular, and peculiar, about photographs is the conjuncture of resemblance and trace – the iconic and indexical components of the sign coincide to a remarkable degree. The resemblance of a photograph to its subject – the image – is a direct and physical result of that subject and could not exist without it. Photographs point to the objects that called them into being and show us those things. As such, photographs bear witness to the events and things they depict.

This conjunction of index and icon in photographic signs – and related media such as film and video – has important implications for how we understand the kinds of pictures that can be produced. It has often been noted that, whereas painters can create imaginary scenarios, invention for the photographer is restricted to dealing with things in front of the camera. As we have seen, Robinson felt that the painter could depict 'angels and cherubim' and so forth, but that the same act would make the photographer appear ridiculous. Painters are free to invent characters, or generate compositions by rearranging, eradicating, or adding objects and forms. Photographers might move a stone or arrange a still life, but they can't move mountains to create more picturesque landscape arrangements. Photography, in contrast to painting, is largely a craft of given forms, rooted in a process of finding rather than

making. In important respects, photographs show us what happened in front of the lens at a particular time in a specific place.

The arrangement of things as they appear prior to the exposure being made is sometimes called the 'pro-filmic event'. This condition results in the principle of recognition in photographs, which allows these images to function as documents. In one sense, the argument for photographic realism is irrefutable: the police use photographs to identify individuals because they record the appearance of *particular* individuals; similarly photographs from the family album were posted to try to locate lost family members and friends after the 2004 tsunami in the Indian Ocean or the al Qaeda attack on the World Trade Center. In this sense, then, the very process of photography, the chemical and optical trace of objects, or the conjunction of iconic and indexical signs, lends support to the common-sense view of photographs as literal or objective copies (and to Bazin's theoretical articulation of this view). Even if we do not fully understand the processes involved, when we look at photographs we realize that the image before us is tied to the things it represents. Truth claims attached to photographs largely turn on this recognition.

Chapter 5
The apparatus and its image

In H. G. Wells's classic story 'The Time Machine', a voyager into the future realizes that he possesses no evidence for his fantastic journey. As he put it: 'If only I had thought of my Kodak! I could have flashed that glimpse of the underworld in a second, and examined it at leisure.' This absent photograph from the caverns of the Morlocks would also have provided proof for the sceptics in his time; instead he had to make do with the, altogether less convincing, memento of a faded, strange flower found in his pocket. As if to emphasize the evidential claim of photography present here, in the recent film version of *The Time Machine*, the time-traveller's camera (which he *has* remembered to pack) is shaken loose from his grip by the violent motion of the time machine. The Kodak is left on the floor in 1895 as the time-traveller lurches into the future.

'The Time Machine' provides yet another example of the belief in the veracity of photographs. Nevertheless, there are plenty of counter-examples to hand that should lead us to question this belief. We know of numerous examples of photographs that have been tampered with, mocked up, and rearranged in order to mislead the unsuspecting. A few examples will have to do to make the point. Amongst the most notorious is the Stalinist airbrushing out of Trotsky, along with other erstwhile revolutionaries, from the documents of the 1917 revolution. In this instance, photographs were painstakingly altered to reinforce an official perspective. It can

be very difficult to prove that photographs have been altered or even set up. For instance, it took doubters decades to demonstrate that the patently faked photographs of fairies made by two young girls in 1917 had indeed been fabricated. Even so, the experts still got their facts wrong. As we will see at the end of this book, the advent of digital images makes this kind of jiggery-pokery much easier. Closer to our own moment, we know the internet contains a sub-genre of 'photographs' of 'naked' celebrities created by joining different heads and bodies (as well as quite a few images of actual naked celebs). The photo 'sting' – in which some prominent individual is drawn into a compromising situation (usually involving sex, drugs, or money) in order to be photographed – is also now familiar.

However, there is another class of images involving less overt examples of manipulation or fabrication. For instance, it has been suggested, both at the time and since, that a photograph taken by H. S. Wong of the effects of the Japanese bombing of Shanghai in 1937 was, in fact, posed. Wong's picture depicts an isolated, semi-naked infant crying amidst the smoky ruins of a railway station. The photographer framed the scene so as to exclude other people from his image and create a greater impression of isolation and helplessness (we know this because another of Wong's photographs that is almost identical includes an adult attending to another child in immediate proximity). He may even have moved the child. In addition, it has been suggested that Wong introduced the smoke. (At least some of these claims are plausible, but when advocated by Japanese historians of a nationalist bent, they clearly involve some axe-grinding.) In this instance, the question that arises is: when does amplification, or selection, become falsification? No sensible person could deny this bombing raid took place, or even that it resulted in civilian casualties, and Wong's decision to exclude some people is the kind of decision photographers make all the time: interestingly, the second image by Wong that is used to cast doubt on this one also includes a dead child draped over the railway track. Nevertheless, some people *do* want to dispute the 'truthfulness' of this image. Arthur Rothstein's

image of drought-stricken America, discussed in Chapter 2, is another example of this kind. Which photographs are challenged as 'untruthful' is often a revealing symptom; sometimes more revealing, or significant, than the image in question.

Even if we put these overtly manipulated cases to one side, there is still a great deal of room for doubt and uncertainty when looking at photographs. Does the image depict what the caption claims it represents? What evidence is there to prove it was taken in a particular place, or at a certain time? Does a photograph of one man standing next to another imply a financial connection, or an intimate relationship, as the editorial line suggests? There is often very little internal evidence in photographs to substantiate the claims made for their content. In many cases, we have to rely on the photographer's, or editor's, trustworthiness (or authority). Whenever an issue is contentious, photographic evidence is likely to be disputed by rival interest groups, political factions, or whatever. Evidence is never simply *in* the photograph.

Evidence is fundamentally a legal category. The current vogue for television forensic science dramas is instructive here. In these programmes, the police forensic team scrutinize a crime scene; determine time and cause of death; detect evidence that is barely visible or even invisible; and find the traces that link a suspect to the heinous events. It is noticeable, though, that these dramas invariably end with arrest and confession, rather than trial, of the suspect. In this sense, they provide a comforting vision of law and natural justice. The court scene would be very different. Almost every point of evidence introduced could be contested; other experts would be called to suggest alternative interpretations from those presented by the prosecution; lawyers would dispute the conclusions drawn; and so on. Photographic, or video, evidence is, likewise, always open to alternative readings. This evidence takes shape in the process of claim and counter-claim.

In contrast to the previous chapter, which presented support for

the common-sense belief that photographs are direct registers of the things they represent, this chapter suggests, above all, that photographs are *pictures*. At least among specialists concerned with photography, this perspective has come to seem uncontentious, even self-evident. These days, most people professionally engaged in photography tend to assume that photographs possess no more inherent evidential worth than pencil drawings. Our culture has, though, tended to naturalize this kind of image. In the process, viewers are liable to fall prey to some powerful ideological effects. In this chapter, I am going to try to denaturalize photography, but I think this is a starting point, and not the conclusion, for an adequate account of photography.

Mirror images

At the heart of any criticism of photographic realism is the idea that the apparatus embodies conventions and assumptions about picturing. While the consequences of the staged, manipulated, or mocked-up image are readily apparent, recognizing the deep conventions underpinning the apparatus can be less straightforward. However, these conventions are no less important for a serious understanding of photographs; if anything, the relative invisibility of these determining assumptions makes them more worthy of attention and more insidious in their effects.

It might help to begin with the mirror 'image': not least because this analogy runs throughout the history of photography, which is often discussed as a 'reflection' of reality. In 1859, Oliver Wendell Holmes went further and described photography as 'a mirror with a memory': his metaphor implies that the photograph is a reflection, but one that has been fixed or frozen in time. In some ways, this is a strong analogy: photographs do seem similar to reflections in mirrors – faithful duplications of reality set beyond a glassy surface. However, the comparison is, ultimately, misleading. One problem is that we need to consider: in what sense is the thing we see in the mirror an image at all? (Here, the word 'image' is used to suggest a

depiction that resembles, or otherwise represents, things that we know or imagine. It is difficult to define an image, but one key characteristic entails a distinction between actual and virtual phenomena.) Assuming a good, flat mirror with a clean surface, there are three factors that enable a beholder to determine that what they see is an image, and not reality itself. Firstly, the bounding edge or 'limit frame' marks the reflection off from the surrounding area. When looking at a mirror, we are aware of its position in a field; its edge produces a disjunction between the reflection and the actual space that surrounds it. Secondly, viewers know from their spatial position that the things reflected (including the self looking) are located on this side of its surface; sometimes this takes a moment to grasp and the effect can be quite disconcerting. Nevertheless, the viewer sees that he or she cannot be here and there. Thirdly, mirrors invert the objects they reflect. In all other respects – principally, because they gather light across their surface – mirrors reproduce the things in front of them in a way that conforms to the characteristics of natural vision. Camera images are of a different order.

An analogy with natural vision underpins many assumptions about photography. It is often said that the camera is a truthful recorder in so far as it reproduces the working of the human eye. This assumption frequently leads on to the related, ideological claim that the camera is a 'mechanical eye'. In this view, the photograph is perceived to offer an objective record because it replicates vision stripped of subjective interference. Whereas the camera had traditionally been seen as an objective device, from the late 1960s film theorists and photo-historians began asking what kind of thing the camera was, what presumptions it was built on. As the critic Joel Snyder argued 'it is ludicrous to believe that a photograph captures images or records them'. His point is that there is no image existing 'out there', which is seized by the camera: rather, the image is *produced* by the camera. This sounds self-evident, but the consequences are very significant – camera-images are not lying about in the world awaiting discovery. (A wide variety of possible

images can be made from any subject.) Images belong to the realm of culture and not nature. Far from accepting the neutrality of the camera, during this period even the most automatic of cameras (surveillance) came to be seen as a cultural apparatus imbued with priorities and presuppositions. This concern dovetailed with the wider interest of the time in the politics of technology.

Camera space

We now need to revisit the provisional account of the camera presented in Chapter 4 and consider the cultural history of the apparatus. The principal difference between camera images and the image in the mirror is that the former – with or without a lens – focuses light at one point. In so doing, the camera produces an image that departs, in significant ways, from natural vision. As we have seen, in its essentials, the camera is just an aperture in a dark box: more or less anything that restricts light will do (the artist Lindsay Seers makes photographs using the inside of her mouth as a camera). The application of a lens to this dark box is not fundamental to the process, but it serves two purposes: firstly, because a curved lens gathers light and focuses it at a point, it maximizes the available light and speeds up the exposure; secondly, the lens decreases the required focal length of the camera (the distance between the aperture or surface of the lens and the film plane), enabling the size of the camera to be significantly reduced.

We will need to return to lenses and their effects, but the basic point here is that the architecture of the camera casts the photograph within a particular history of images. Joel Snyder, who, I think, has provided the most thoughtful account of the camera, suggests we tend to see the history of this instrument from the wrong end. The camera is frequently viewed as providing a confirmation of the principles of Western painting. Snyder suggests that the problem is the exact opposite: the camera evolved (over a protracted period) to reproduce the characteristic features of Western art. Pinhole phenomena and the camera obscura had both been familiar to

optical experimenters for a long time, particularly in Arab civilization, but it was not until the 16th century that they began to be discussed in conjunction with *pictures*. The pictorial use of the camera obscura belongs to a point *after* the basic conventions of Renaissance painting had been consolidated. As Neil Walsh Allen and Snyder have pointed out, the camera lens gives a circular image, becoming more diffuse at its edges, but, very early on, photographic cameras were fitted with a square or rectangular viewing screen. In conformity with paintings, drawings, and prints, this screen only makes visible the central portion of this image. In trying to account for this new type of image, photography's experimentalists fitted it into the existing account of pictures.

The point to be grasped is that the Western picture is a conventional construction and not a natural category. The system of 'linear perspective' is at the heart of this kind of picture. Perspective has been much debated and disputed, but we need to consider some of its principles, because the camera obscura and the modern photographic camera are predicated on them. (At a later point it will be necessary to ask what exactly is meant by 'conventional', because this is often simplistically equated with 'arbitrary'.)

Perspective is said to have been discovered by the architect Brunelleschi in c. 1415 and codified in Leon Battista Alberti's treatise *On Painting* of 1435–6. For Alberti, observers take the measure of space through a series of visual rays connecting the eye to particular bodies. (There is some dispute about whether Alberti's account has anything to do with 'images', but I am going to pass over this.) He suggested that there were three types of rays: extreme or extrinsic rays measured the edges or outlines of an object or space; median rays filled this outline – Alberti seems to have associated them with the perception of colour; the centric ray touched the centre point of a plane and marked equal right angles around itself. It is fascinating to imagine with Leonardo da Vinci

17. William H. Rau, *New Railroad*, Duncannon, Pennsylvania, c. 1890–1900

that 'The air is full of an infinity of straight and radiating lines intersected and interwoven with one another without any occupying the place of another'. Before we proceed, I must acknowledge a problem. Twentieth-century physics has demonstrated that there is no such thing as an individual light ray. The behaviour of light is very complex; in some situations physicists treat it as if it were an electromagnetic wave; in others, as though it were a quantum particle. However, in neither case is light assimilable to the independent, straight lines of perspective theory. Most readers will be glad to hear that I am not going to elaborate on this subject: in what follows, I use 'light rays' to refer to the ideas of perspective theorists; in all other instances, I will simply speak of 'light'.

Renaissance perspective was rooted in classical geometry and its underlying assumption was that perception of the external world

took the form of a triangle or pyramid. As Leonardo put it: 'By a pyramid of lines I mean those which start from the surface and edges of bodies, and converging from a distance, meet in a single point.' That point was situated at the eye. In this sense, vision was like, to use an anachronistic example, a searchlight, sweeping across space and isolating particular things; taking their measure. The picture was envisaged as 'a cut through this pyramid in some definite space' or 'a certain cross-section of a visual pyramid'.

In linear perspective, the illusion of recession is created by a geometrical principle in which all perpendiculars, or orthogonals (parallel lines at right angles to the picture plane, or field of vision), meet at a vanishing point (for horizontals that point is located at the horizon). If we imagine a room depicted in this fashion, the interior walls, which we presume to be parallel, appear to slant inwards and decline in size along their top and bottom edges. This geometrical model allowed artists to produce a convincing illusion of spatial depth by plotting relative scales for bodies within a regular geometric grid: the further an object was supposed to be from the observer, the smaller it appeared.

On the basis of this model, Alberti suggested: 'First of all about where I draw, I inscribe a quadrangle of right angles, as large as I wish, which is considered to be an open window through which I see what I want to paint.' This metaphor of a window is central to our conception of the Western picture – *perspectiva* is Latin for 'seeing through' – and has been carried over into photography. The window metaphor effectively naturalizes the artifice of the Western picture, claiming for it the status of reality or, at least, of a perfect duplication of reality. A window pane separates us off from the outside world, but the transparent glass offers no barrier to our eye: we look through the window onto a portion of the world. When we add to this the window frame that demarcates a 'view', we can see why this metaphor has had such a powerful effect. The Albertian window suggests that the surface of the picture is transparent; the picture frame, like the window frame, bounds, or contains, the

prospect, but the view appears as a perfect re-presentation of the things on the other side of the window. Leonardo summed up this attitude well, claiming:

> Perspective is nothing else than seeing a place or objects behind a plane of glass, quite transparent, on the surface of which the objects that lie behind the glass are drawn. These can be traced in pyramids to the point of the eye, and these pyramids are intersected by the glass plane.

In some ways, however, what I have been saying is incorrect or, at least, inexact, because the reality in question was not our modern, empirically testable world, rather it was an ideal or abstract view corresponding to the all-seeing eye of God. Nevertheless, as the precepts of Renaissance perspective were carried over into the modern world, the view through the window accrued the sense of empirical reality.

In the words of Erwin Panofsky, the great historian of this system, perspective conveys, above all, a new rational and rationalizing, mathematical system of visualizing space: an 'infinite, unchanging and homogenous space'. That is to say, perspective space is ordered according to the logic of geometry: it was, Panofsky argued, not 'given space, but space produced by construction'. The chequered floor tiles that feature in so many Renaissance paintings can be seen as the leitmotif of this rational construction, since they provide a systematic illustration of the system itself.

If we look at Antonello da Messina's painting *St Jerome in His Chamber* of c. 1475, we will get some sense of these conventions in practice.

This demonstration piece makes a display of many of the features of the perspective system. Antonello set his St Jerome in the centre of a large sweep of space, reaching from the objects on the foreground window ledge to the mountains in the far distance. It is

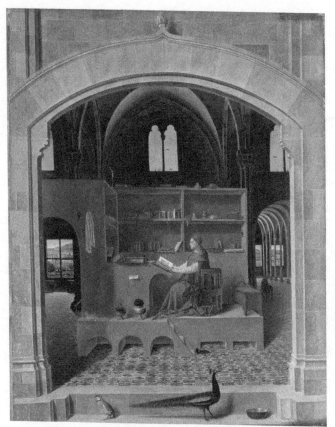

18. Antonello da Messina, *St Jerome in His Chamber*, c. 1475

worth observing that he is able to sustain an attention to detail, or optical focus, across most of this space. Recession is principally conveyed through linear perspective: the orthogonals meet at a concealed vanishing point a little to the left of St Jerome's head; the overall space has a sense of a box-like construction. Panofsky said that 'like all Italian interiors, it is basically an architectural exterior with the front surface removed'. But, unlike most Renaissance

painters, Antonello went out of his way to display this system. He painted in the window frame, which has an imaginary status in most other paintings: we can imagine climbing through it into the space behind; the floor tiles, once again, codify this spatial system by rendering the organizing orthogonals visible. They also help clarify what it means to say that the system of linear perspective is a conventional system. Complex floor patterns, like this, have been reconstructed from their representations in paintings. In this sense, perspective accurately conveys some information about the world – in so far as it is a conventional system, it is not an arbitrary one, but a system like its parent mathematics.

What is really important about Panofsky's account is that he argued that perspective was not a copy or literal re-presentation of reality – he called it a 'Symbolic Form', meaning an organization obeying specific cultural and historical values. There are two ways to illustrate the conventional character of this system: the first is to compare it to other representational systems; the second involves a contrast with natural vision. Panofsky explored both options. Pre-Renaissance painting, along with painting developed in other cultures, frequently follows a different set of rules to those pursued by the Renaissance painters and theorists. It is tempting to find these other systems of art wanting in comparison with the art of 15th-century Italy, as though these artists tried to make works in linear perspective but failed. However, these image systems are not inadequate versions of Renaissance art: they embody a different vision. For instance, while orthogonals often converge in pre-Renaissance art, they do so inconsistently: a picture frequently contains a number of inconsistent vanishing points, or points of convergence. It has been argued that the Russian Icon tradition employs a system of inverted perspective, with the orthogonals diverging in the picture – the point of convergence appears to be the position of the spectator. (One account suggests that the point of view in the Icon tradition corresponds to that of God or the Saint looking out from the picture.) Works in the Chinese, Japanese, or Persian traditions are not organized around a central vanishing

point and do not always distinguish scale from foreground and background. Panofsky's own example was drawn from the art of classical antiquity, which he believed revealed a psycho-physiological conception of space, in marked opposition to the coherent and rational space of the Renaissance. He suggested that these pictures possessed no cohering centre or horizon; rather they followed a different model of space which sustained discrete points of attention. Spatial unity does not seem to have been valued by these artists or their viewers. Panofsky claimed these pictures were organized according to the way our bodies actually relate to things in space: switching attention between this and that in a discontinuous field. Panofsky felt that Renaissance perspective was neither natural nor inevitable; rather, it was the historical product of a society that valued detachment more than immersion; order rather than flux; regularity instead of discontinuity; and structure over experience. At this point, we ought to be able to see that the modern photographic camera is modelled on a particular rationalizing order of space (it inherits a 'Symbolic Form').

'Natural vision'

The values embedded in the camera can be drawn out through another line of inquiry, which entails contrasting the camera image with 'natural vision'. In doing so, there is a danger of setting up natural vision as a standard against which to judge representational forms. That is to say, it is tempting to regard any image that deviates from vision as a distortion of reality and hence as inadequate. But, as we learn from Benjamin, photography provides a powerful supplement to natural vision, enabling us to perceive things that remain imperceptible to the 'naked eye'. The value of a visual form does not depend on adherence to, or departure from, human perception. Nevertheless, because photography has frequently been seen through an analogy with natural vision, it may be helpful to outline some significant distinctions. Paradoxically, I am going to do this by focusing on a photograph that *does* attempt to reproduce

the conditions of perception following Helmboltz's theory of vision: P. H. Emerson's *A Stiff Pull* of 1888.

Emerson, an advocate of Naturalism (a version of late 19th-century art-photography), reacted against the prevailing taste of the period and tried to model his images on the way a scene would actually be perceived: *A Stiff Pull* is a good example. This image, in some ways, differs from most photographs. The picture depicts the moment at which two plough-horses reach the brow of a hill. But it ought to be apparent that he has done a considerable amount of after-work on negative or print. Notably, there is a very shallow depth of field – only a small portion of the image seems to be in focus (the plough as it meets the earth and the patch of ground to the right). This is odd, because even with a shallow depth of field, we would expect the point of focus to be the same across that plane. Emerson has worked (probably on the negative with an abrasive) to ensure that everything to the left of the plough is hazy. The effect is to direct attention to a small segment of the image.

19. Peter Henry Emerson, *A Stiff Pull*, 1888

As I have suggested, the eye has frequently been compared to the camera obscura, and the photographic camera; in some ways the analogy makes sense. Like the camera, light enters the eye (a dark chamber) through a lens, the pupil acts as a diaphragm regulating the amount of light admitted, casting an inverted image on the retina. Pushing the analogy a little, we might even see the eyelid as a shutter. In other ways, though, the comparison is quite misleading. Our perceptual apparatus consists of three interlinked components: the eye is only the first of these. The optical image formed on the retina is translated into chemical substances which transmit information, via the optical nerve, to the nervous system of the brain. Whereas the camera is designed to produce images, we do not see the retinal image. Rather, what we experience is the outside world as it is perceived in the brain: this involves, among other things, turning the retinal image the right way up and amalgamating two distinct 'images', each possessing their own visual field. Analogies between eye and camera take us so far, but they involve separating the eye from its place in perception. Isolated, in this fashion, we would have to say that the eye is blind.

Some distinctions between human visual perception and the camera image are obvious: i) the eye registers colour and light and dark simultaneously, whereas black-and-white photography records luminosity devoid of colour; ii) we perceive a shifting field and not a square or oblong framing edge; iii) human vision is binocular, rather than monocular: looking with two eyes spaced roughly 6 centimetres apart allows us to register spatial depth. This has important consequences for looking at pictures, because binocular vision enables us to see the flat picture surface as well as the depicted scene. (Even when looking into a mirror, we sense the presence of a flat surface.) Other aspects of visual perception might be less apparent, but they are no less significant. Firstly, human vision focuses on a single plane rather than deep space (place your finger before your eye and try to focus on it and a more distant object simultaneously); we compensate for this with rapid eye movement, which gives an illusion of continuous perception. Our

eyes are constantly in motion (so are our bodies and heads), resulting in a flickering, jerky perceptual experience. As such, we tend to observe discrete points of focus rather than a homogenous field (this relates to Panofsky's point about pre-Renaissance painting).

This is exacerbated by the perceptual process called foveation. The fovea centralis is a particular indentation on the retina along the axis of the eye's lens, particularly rich in receptor cells: it is at this point that the 'image' is 'sharpest'. When we wish to see something clearly, rather than move the eye, we turn our head; in this way, the object under scrutiny lines up directly with the fovea. Perceptual investigators call this the 'point of fixation'. As such, human vision is marked by both central and peripheral fields of attention. Peripheral vision is much less distinct than central vision, and colour perception is considerably reduced there. Nevertheless, peripheral vision plays an important role in perception, allowing us to detect movement or the presence of objects; it is very important for spatial manoeuvring and sensing potential hazards. We should also note that spatial perception isn't just visual: humans are embodied creatures who orientate towards the world through our bodies as well as visual prompts.

It ought to be apparent that Emerson's attempt to model the photograph on a particular conception of the retinal image was quite batty (though, it is no worse as a *picture* for that). He isolated a couple of features from the perceptual process (the distinction between central/peripheral vision and the idea of selective points of fixation) and made these stand for perception. However, we look at pictures in the same way that we see the world – with continuous eye movements and shifts in the point of fixation. Emerson could not hope to mimic this in a still photograph. Effectively, he froze the motion of the eye. Understanding this may help us to grasp the tricky nature of perspective. If we return to the painting by Antonello, or any photograph with an extensive depth of field, we can observe a contradiction: *St Jerome in His Chamber* conveys

detail across a vast expanse of space. The partridge in the foreground, the columns, St Jerome's book, even his lion set deep in the picture, are all depicted with almost equal attention. But, as we have seen, the human eye is incapable of holding focus across space. The sleight of hand here is that we perceive these things in equivalent detail because they are depicted on a flat surface, which our eye *can* focus on. The intense sense of depth and detail that we experience in front of paintings or photographs is a result of their flatness.

One last point on perspective: theorists have long distinguished between *perspective naturalis* and *perspective artificialis* (natural and artificial perspective). In human vision orthogonals do appear to converge in the distance (look along a railway track or up at a tall building), and this gives a sense of diminishing size. This natural perspective is based on angles of vision. The artificial perspective of the Renaissance painters and the camera, on the other hand, is a conventional system (organized around a central vanishing point) designed for plotting diminishing scale on a flat surface. In contrast to human vision, linear perspective creates a geometric box-like space. The powerful analogy between camera and eye has the effect of naturalizing photographs and rendering it difficult for us to see them as *pictures*. Photographs are not reproductions of vision; rather, they present information to vision.

'Reality effect'

The photographer Henri Cartier-Bresson once described photographs as the 'meeting of an instant and geometry'. His point is poetically put, but it captures something of photography's position at the juncture between contingent events and the rational order of linear perspective. Part of the fascination of photographic pictures is that they appear lifelike, but, somehow, much more so. Looking at pictures is, in this sense, akin to dreaming or the drifting consciousness experienced in moments of reverie. Advertising and pornography clearly play off this odd condition somewhere

between waking reality and dream or fantasy. Photographs – their glossy surface and high key colour only adds to this – can seem more real than reality: uncannily like the world we know, yet more perfect, ordered, and coherent. One reason for this is that the system of perspective, by encompassing the viewer into the visual field, makes him or her appear to be the singular recipient of the information presented. Perspective images address each viewer in exactly the same way and yet, at the moment we look into them, everything appears designed 'especially for you' (this has been characterized as an 'individual effect'). The image seems to address us as unique individuals, but it does this for every single viewer. It is a space that seems particularly amenable to fantasy or ideology. The proviso is that no one ideology – not even 'individualism' – spans the period of the Western picture. It may be, for instance, that perspective is conducive to historical thinking, or to grasping the value-laden character of points of view. A perspective or point of view suggests (if only negatively) the possibility of other places from which to look, or the difference between here and there.

Let me return, one last time, to the correlation of eye and camera. As we noted earlier, the camera cannot be viewed as a corroboration of the Western picture; instead, it was designed to reproduce that model. Lens configurations are instructive in this regard. There are three basic lens arrangements available for the camera; each results in a different kind of image. Lenses are measured according to their focal length (the distance from their surface to the film plane). One lens type is usually designated as a 'wide-angle' lens (a focal length of less than 35 millimetres). Lenses of this type allow a wider field of view and are particularly useful for photographing in confined spaces. Wide-angle lenses stretch space, increasing the sense of depth (they are a real boon to estate agents). The second variety of lens, typically referred to as 'normal' or 'standard' has a focal length in the range from 35 to 55 millimetres. This lens is the one most frequently fitted to cameras. The third lens configuration is usually described as 'telephoto' and has a focal length in the range from 60 to 1,200 millimetres. (For ranges above this, the camera is

typically fixed to a telescope.) Telephoto lenses allow distant objects to be photographed as though they were nearby: in doing so, they compress space, bringing widely separated objects into close alignment. Obviously, the selection of lens type will have a determining effect on the image. If a photographer intends to suggest a relationship between two people (real or constructed), a telephoto lens will convey this better than a wide-angle lens. But over and above this, there are no prizes for guessing which of the three lens types most closely mimics the human eye. In an important sense, the conflation of camera and eye generates, to take a term from film theory, a 'reality effect'.

The idea of a 'reality effect' was developed to describe the ideological effect of a system of representation (film) that is sometimes confused with a literal copy of reality. In one sense, the reality effect corresponds to Alberti's window. Documentary photography particularly trades on this effect, as do photography's fantasy forms. What we see is a highly conventionalized image, but one that seems to copy reality: either because it shares some characteristics with the objects or events depicted, or because it has been naturalized over time. At the end of the 18th century, one treatise on perspective suggested: 'a Picture drawn in the utmost Degree of Perfection, and placed in a proper Position, ought to appear to the spectator, that he should not be able to distinguish what is there represented, from the real original Objects actually placed where they are represented to be . . . '. We know that this idea is fanciful – binocular vision alerts us to the presence of a flat surface – but it conveys something of the reality effect, which works to conflate the gap between the object or event depicted and the resulting image. Ideologues of all stripes have a vested interest in the associated claim that 'the camera never lies'. To be able to say 'this is just the way it is' or 'but it was captured by the camera' is a very good way of masking highly contentious and interested points of view.

Whereas advertisers, pornographers, and suchlike employ the

reality effect to induce us to identify with commodities, some artists have used it to quite different ends – to call attention to ideological investments in images. The novelist W. G. Sebald, for instance, regularly employed banal photographs to illustrate his odd narratives and travelogues. However, on reflection, it seems most likely that he invented elaborate scenarios and narratives around found photographs (the pictures sometimes don't seem credible as illustrations). Sebald's books employ our belief in the veracity of the photograph to draw us into the narrative, while allowing the moments of disjuncture and implausibility to pull us up short, inducing us to reflect on the relation of image and text, or what is said and what shown.

Frame

The frame plays a central role in photography, perhaps even more than it does in painting. It may be helpful at this point to distinguish between the 'object-frame' and the 'limit-frame'. The 'object-frame' might be ornately carved and covered with gold leaf, or a plain metal or wooden construction. In photography the masked white edge of a print is also a frame of this kind. The object-frame calls attention to the picture, isolates it from the wall, and offers some protection against bumps and bangs, smudges and fingermarks. In contrast, the 'limit-frame' demarcates the compositional edge of the picture. Limit-frames are compositional devices separating inside from outside; picture from pro-filmic event. As Szarkowski put it, '[t]he central act of photography, the act of choosing and eliminating, forces a concentration on the picture edge – the line that separates in from out – and on the shapes that are created by it'. Whereas the painter fits his or her compositions into the selected canvas (often working with the edge or limit-frame as a key point in the overall organization), photographers work somewhat differently. The limit-frame in photography is initially constituted by the edges of the film plane as it appears in viewfinder or glass screen. There is subsequently scope to change this in the darkroom, by printing only a section from a

negative. In either case, the final limit-frame coincides with the edges of the photographic print.

In fitting a contingent view into the limit-frame, photographs isolate and focus attention on fragments of things. 'Photography is', to cite Szarkowski again, 'a system of visual editing. At bottom, it is a matter of surrounding with a frame a portion of one's cone of vision, while standing in the right place at the right time.' Whereas paintings are built up, photographs are extracted from a visual field. The best way to think about the limit-frame in photography is as a kind of excision in space. This 'cut' extracts a portion of space, while suggesting that it is a fragment of a much larger field of view. Changes can be made in the darkroom, but at the initial stage photographic composition basically comes down to deciding which portion of the pro-filmic event to include and how exactly to deploy the limit-frame. This restriction has provided the basis for images of a startlingly novel type. Conventional pictures typically centre the principal subject and build the composition around it; the camera, at least potentially, implies a fluid framing procedure and a limitless number of alternate framings. Consciously, and unconsciously, 20th-century photographers have made use of these possibilities by pushing the subject up to the edge, leaving a central void ('deframing'), or slicing through a person so that only part of a figure appeared within the frame. Heads are lopped off; hands or feet project into the picture from beyond the depicted space; objects fill the entire frame (close-ups); two different bodies might be aligned and space compressed so that foreign objects appear to sprout from the body (sometimes called 'false attachments').

We may be able to clarify the working of the limit-frame by looking at a famous example from Alfred Stieglitz's series, which he called *Equivalents*.

The *Equivalents* are all just photographs of clouds. Stieglitz intended these pictures to be interpreted as expressive correlates or

20. Alfred Stieglitz, *Equivalent*, 1930

equivalents for his feelings or states of mind, but this need not concern us. What is striking about these images is the central role played by the limit-frame in their production. In one sense, these pictures are nothing but their frame: Steiglitz has created these shapes and forms by using the frame to select and isolate a fragment from the expanse of cloud and sky; imposing aesthetic order on chaos. What we see only takes shape in the photograph. The *Equivalents* were some of the first self-conscious experiments with photographic composition as a 'cut in space'.

As we saw in Chapter 3, Szarkowski argued that this kind of framing constituted one of the inherent properties of the photographic medium. But the understanding of the photographic frame and its implications needs to be seen in historical perspective. Throughout the 19th century, photographers employed the most conventional compositional techniques, particularly centring whole figures. Even Stieglitz – in

the front rank of arguing for art-photography – prior to the *Equivalents*, had conformed to the standard forms of composition. This kind of framing is one potential way of using a camera, but it is not the only one. Nevertheless, this kind of procedure does highlight the role of the frame in making a picture. The frame, whether used conventionally or not, is a rhetorical device that makes connections where none necessarily exist. Photographic meanings are often built from these connections, and they play a very prominent part in the lexicon of street photography. Doisneau's *Helicopters, Tuileries Gardens* of 1972 is a good example.

The connection between the two key components of this image – the helicopters and the statues caked in guano – is created by the frame. These things are contingent and unrelated, but the frame binds them together, establishing a powerful association. The effect is to prompt the viewer to transfer the values of one thing to the other. In this case, we can't help feeling that the military 'birds' have crapped on classical culture. With the choice of the frame, the photographer actively makes the picture rather than simply recording pre-existing things. Photographs unavoidably necessitate the problem that H. S. Wong was criticized for.

Narrative

So far we have assumed that photographs produce meanings independently of language; this is an abiding assumption (associated with modernism), but it is seldom, if ever, the case. Photographs invariably come coupled with headlines, captions, titles, or descriptions. The half-tone screen, which enabled the easy combination of photographs and words, entrenched this relation and made the symbiosis of image-text a powerful cultural force. Even when photographs are not provided with accompanying text (sometimes on gallery walls or the odd advertisement), the viewer brings experiences and beliefs with them; we fit the image into narrative contexts.

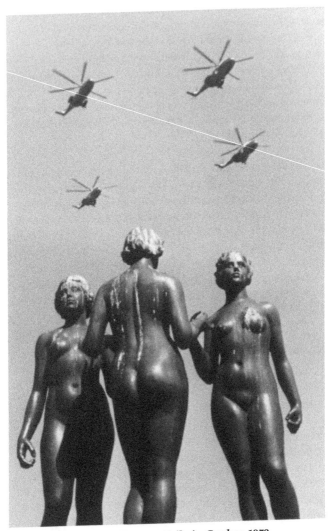

21. Robert Doisneau, *Helicopters, Tuileries Gardens*, 1972

The case of the news photograph is particularly instructive in this context. Roland Barthes suggested that the caption 'anchored' the image: that is to say, that the caption or headline tied the image down to a preferred interpretation. The exhibition *From the Picture Press*, curated at MoMA by Szarkowski in 1973, is revealing in this regard. This exhibition consisted of press photographs stripped of their captions and removed from the newspaper layout. Presented in this form, the images seemed strangely ambiguous and formally peculiar. In the process, Szarkowski intended to reveal the essential formal characteristics or properties underpinning all photographs. He systematically denied that photography was a narrative form and repeatedly pointed to its lack of immediate legibility. Photography, according to him, was an art of details and fragments and not an art of storytelling. (One of the things that picture editors do is combine images in striking juxtapositions or in sequences which establish narrative threads. It is telling that photographers have frequently complained that, in the process, their work is misrepresented.) As a claim about photographic art, or for the core condition of the medium, Szarkowski's procedure is highly dubious: *From the Picture Press* extracted instrumental press pictures from the contexts and uses in which meaning is constructed. However, his exhibition did have the virtue of demonstrating the semantic vagueness of photographs not pinned down by caption and text. It reveals, once again, that meaning is not simply *in* the image.

A number of artists have similarly experimented with news-photographs shorn of their anchoring text. Sarah Charlesworth's *Modern History* of 1977–9 reproduces the front page of 45 newspapers from around the world. Charlesworth left the title of the paper, but removed all other news copy. Each example includes an image of Aldo Morro (at the time he had been kidnapped by the *Brigada Rosso*). Frequently, this picture appears in incongruous combinations with other images. In John Baldassarri's video *The Meaning of Various News Photos to Ed Henderson I*, of 1973, the said Henderson is invited to describe news-photos cut from their context and pinned up. The descriptions are remarkably

circumspect and the narrator often circles around, revising his assessment of what he sees: in one instance, he seems unable to decide if a man has been shot or has simply spilled his bag. His descriptions are hardly convincing. In a related context, Larry Sultan and Mike Mandel's book *Evidence*, from 1977, culled 50 photographs from US government archives and presented them without acknowledgment of their institutional context or any textual information. Shown in this form, it is not at all clear what the photographs are evidence of or for. These projects all reveal how little we can rely on photographs when they are divorced from supporting information or establishing contexts.

One way to envisage the difference between 'art' and 'documentary' in photography turns on this relation to language and narrative. In the main, documentary is a closed form, designed to produce preferred interpretations. As such, images are usually combined with some form of anchoring text that steers the viewer/reader in a particular direction. Photographic art, in contrast, typically abjures words, or employs elliptical text, in order to leave the image open to associations and interpretations. For art, vagueness or ambiguity are often the preferred modes. Advertising can be seen as an intermediate form that offers a certain amount of semantic play and open connotation, but with the aim of transferring the associations generated to the commodity being promoted.

In this sense, we can see why it is possible for newspapers with very different editorial lines to sometimes employ the same dramatic picture, because the caption is used to prompt a conclusion. The morning after the US presidential election of 2004, one right-leaning British newspaper printed on its front page a picture of George W. Bush and his family, which was much like all the others. The image was accompanied by a headline that ran: 'Family of Scroungers'. In fact, this caption related to another story, featured on the same page, about a British family who, it claimed, was drawing extensive state benefits. However, the effect was entirely different: we can only presume that the subeditor was having a

laugh at the expense of the paper's editorial policy. Switching captions, or inventing new ones that suggest a different editorial perspective, can be as instructive as it is often funny.

It is, though, important not to carry this argument too far. It is one thing to suggest that the photograph is not a narrative form, or to argue that the caption is essential to the editorial line, but it is another to say that the image presents no evidence or corroboration for events. Mandel and Sultan's *Evidence*, Baldassarri's video, exhibitions by Szarkowski and Charlesworth can all help us to grasp the processes involved in the production of photographic meaning, but there is a danger that this approach can be over-extended. Art trades on indeterminacy, but the demystifying works by artists can lead to cultural and political myopia when transferred to other contexts. An adequate account of photography must resist the imperialism of art. In contrast, W. J. T. Mitchell reminds us that when images are put into some relationship with words, the caption can only retain some credibility if, in some sense, it corroborates what there is to see.

Chapter 6
Fantasy and remembrance

Fiction

In his text 'Digressions on the Photographic Agony', written in 1972, the artist Hollis Frampton posited the paradox of an imaginary world recorded in photographs. Frampton narrates the discovery of a huge floating sphere, which turns out to be the long-submerged Atlantis. On investigation, the hollow globe contains just ballast and a huge archive of old photographs. No one seems interested in these images and they are dispersed – some to museums, some to gather dust in middle-class attics – then a young PhD student advances a startling hypothesis. The Atlantean repository is a fictive archive in which events, places, and people were staged, in order to be photographed. Full-scale models of cities and an array of historical characters were all created in this way. It turns out that what the images represent is world history from 1835 to 1917, but now that history takes on a strange and imaginary form, as though it had never taken place, or had only ever existed as images. (This conception is akin to the 'replicants' (artificial humans) in the film *Blade Runner* who are supplied with fake photographs as corroboration for their implanted memories.) Presumably, because this is Atlantis, the events were staged long before they actually occurred.

When Frampton wrote this text it was a striking premonition of

what modern image-culture would become: after all, we now live in a time when politics often appears little more than a string of 'photo opportunities'. Politicians kiss babies, and visit hospitals or schools, in order to be pictured as the kind of concerned people who kiss babies, visit the sick, and show an interest in the future generation's education. We inhabit a culture so saturated with media images that it hardly seems remarkable when a British Home Secretary turns up (with a photographer) at a search for 'illegal immigrants', or when 'smart bombs' relay pictures of their own spectacular and devastating impact. Staring out at us from the tabloids and their glossy kin are photographs of people, famous for nothing but being out and about. We know what it means to watch people perform themselves for the camera. In part, we understand this because we do it ourselves: striking a pose or adopting a 'look'. In these instances, photographs seem to have become wrapped up with events, generating rather than recording them.

The development of huge corporate image banks such as Bill Gates's 'Corbis' and 'Getty Images', which buy up photo archives and commission stock images, are having an enormous impact on the uses of photography.

These super-archives now constitute a multi-million-dollar industry. The commercial ownership of historical image collections, obviously, has significant implications for the control of memory and the representation of history; all manner of publications increasingly draw their illustrations from these sources. The stock pictures are all high-colour photographs, often digitally enhanced, representing a perfect world filled with beautiful people, beautiful places, and stunning light. Conflict is replaced with hedonism and good teeth; commodities, like Venus, seem to spring, magnificent and fully formed, from the waves. Culture seems increasingly colonized by an advertiser's vision of a retouched world. In the light of these developments, it is difficult not to see Frampton's story as remarkably prescient. Photography now looks less like a copy or

22. Image of a woman on a beach, from the Corbis agency

trace than a total fabrication, or a 'reality effect' that purveys a fictive world.

In the past the predominant model of photography was drawn from documentary, now advertising and its cognate publicity forms have assumed the central role. These profoundly ideological images demand serious attention, but some problems are likely to result if we view the whole photographic field through these fantasy pictures. Attention to the fictive constitution of photographs is important because the common-sense conception tends to see only the objects and people depicted in the image and overlooks both the interventions of the photographer and the specific character of the photographic apparatus. The resulting conflation of photographs with the pro-filmic event leaves the viewer open to propaganda of all kinds. Focusing on the cultural construction of meaning in photographs can help us resist this effect. The feminist discussions of Sherman's pictures, or the work of contemporary artists, provide useful models for thinking about a photograph's ideological connotations. There is a cost, though, and it may be overly high. Sceptical views of the photograph always run the risk of ignoring the

particular forms of evidence embodied in photographs, disabling memory and testimony. Frampton's projection is good fun, but, in one sense, it is a preposterous invitation to imagine the horrors of world history as mere images. (Writers on photography have been rather too keen to countenance such an idea in recent years.)

The case of the 'trophy images' made by US military personnel depicting the abuse and torture of Iraqi prisoners in Abu Ghraib prison, and other locations, are highly significant in this respect. These pictures have been compared to pornography, but they seem closer to tourist pictures. They are snapshots intended as private memorials of victory and American superiority for the folks back home. They proclaim: 'look where I went', 'look what I did'. (It strikes me as profoundly odd that they news media digitally obscured the genitals in the published versions of these images, as if *that* was the obscenity). However, once these pictures surfaced they were taken as evidence of criminal acts and prosecutions ensued. That is to say, the pictures are treated as independent witnesses to these events. While these images may be pictures, they are pictures of a peculiar kind that record the specific traces of individuals and situations. No doubt, had they been able to do so, the American and British authorities would have been only too happy to dismiss *these* images as fictions. In fact, they elected not to dispute that prisoners had been severely maltreated – they accepted the photographs as evidence - but to try to localise these crimes to specific 'bad apples'.

In this instance, to deny evidential status to photographs seems profoundly misguided, if not downright complicit with the events depicted. The same point would stand for Holocaust images and other photographic records of atrocities. While there are very good reasons to be suspicious of the supposed neutrality and objectivity of photographs, there is a danger of throwing the proverbial baby out with the bathwater. Opponents of repression and exploitation around the world constantly need to

23. Abu Ghraib prison, Iraq

appeal to evidence on behalf of the victims of violence, whether sponsored by states, corporations or private gangs; photographs are likely to continue to play a prominent role in contesting the effects of power. In my view, we need to bear this argument in mind, when we consider the veracity of photographic images.

The preceding two chapters placed a very different emphasis on the interpretation of photographs. Chapter 4, following Peirce, suggested that we view photographs as transcriptions or records of a pro-filmic event. Chapter 5, in contrast, emphasized some of the ways that the photographic image must be understood as a conventional construction, embodying specific values and priorities. Both of these perspectives are rooted in observable features of the medium; there seems to be no simple way to reconcile this contradiction.

The artist Jeff Wall provided a good formulation for this conundrum when he said that there are two prominent myths about photography: the myth that it tells the truth and the myth that it doesn't. Wall's characterization has the merit of capturing something of the paradox involved in looking at photographs, since these are images that do not seem to be images. Another photographer, Allan Sekula, has suggested, however, that, at least for intellectuals and media professionals, in the contemporary ideological climate these myths do not hold the same cultural weight: '[t]he old myth that photographs tell the truth', he suggests, 'has succumbed to the new myth that they don't'. It is my argument in this short introduction that the most productive way to view photographs is to hang on to the contradiction or tension between the two myths; to pay attention to the contradiction between the pro-filmic moment and the form imposed on it by the photographer and his or her apparatus. While photographs are copies of their pro-filmic moment, they are never unmediated copies of it. As we have seen, the apparatus is built on some deep pictorial foundations. Photography is, then, always a doubled or paradoxical form: the image is a transcription of a bit of the world and, at the same time, a picture shaped by the determinants of the apparatus and the choices made by the photographer. Maintaining this double focus requires effort and attention; failing to do so gets the viewer caught up in all sorts of problems.

Time and place

As we have seen, Peirce suggested that indexical signs are linked to a definite time and place. In this sense, because of the close correspondence between the indexical and the iconic element, photographs depict a fraction of time. Even the constructed photograph represents a definite moment. The events we see in photographs happened, and the image stands as testimony to their occurrence. As a number of observers have noted, the time objectified in photographs is, though, strangely paradoxical because the things and events we see in photographs have *already* happened. As Roland Barthes, in a highly influential account, argued: '[t]he type of consciousness the photograph involves is indeed truly unprecedented, since it establishes not a consciousness of the *being-there* of the thing (which any copy could provoke) but an awareness of its *having-been-there*'. Photographs, he said, conjoin 'the *here-now* with the *there-then*'. The image may display the 'decisive moment' of a car crash, an execution, or climax of a sporting event, but the occurrences represented have already taken place. The vehicle is now in a scrap yard, the man or woman in the grave, and the race won or lost.

For many commentators, this peculiar temporal conundrum – the condition of simultaneously being of the past and appearing in the present – defines the photograph as a melancholic form that, above all, conveys death and loss. The hubris of photography can be exemplified by the encounter with old photos in a junk shop. This encounter with congealed memories – the happy moments of festive days – often induces a kind of melancholy recognition in which dog-eared images take their place along with all the other detritus of lives past. An old daguerreotype of a butterfly collector has always fascinated me in this regard. This portrait records a man proudly displaying his valued collection. But we realize that he now represents for us what a prized butterfly was to him, a dead specimen under glass. Barthes associates the photograph with

'trauma', 'wound', and 'death', while Bazin identifies it with 'embalming time'; writing in 1840, the eminent British scientist Sir David Brewster used this same image of embalming to account for photography. For these writers, even the most happy and innocent photographs – perhaps especially the most happy and innocent – function as a kind of *memento mori* for the viewer's own death, reminding him or her that all things pass and fade; that life is just a snapshot.

There is, though, an important consequence of Barthes's influential account of the experiential time in photography that is rarely noted: his account isolates the present from the past. So, he writes of one photograph 'I shudder over a catastrophe which has already occurred'. This perspective has the effect of creating a safe distance between himself and the depicted events, but at the cost of blocking the image from entering into our time. ('Trauma' seems the wrong image for this vision, because trauma is precisely typified by an inability to leave the past behind.) Barthes works overtime in his book *Camera Lucida* to deny the photograph any possible efficacy in the present: '[t]he photograph does not call up the past' and it does not 'restore what has been abolished (by time, by distance) but to attest to what I see existed'. According to him, the photograph 'is *without future*'. For Barthes, the photograph acts as a reminder of the passing of things.

Despite the influence of this argument, this melancholic conception is open to dispute. If photographs encapsulate the peculiar temporal paradox of *here-now* and *there-then*, by definition, this condition must work both ways round: as much as the image conveys something of death, reminding us of the unstoppable passing of time, it simultaneously brings a moment from the past to life for us, 'blasting' it up in the present, as Benjamin would have said. Benjamin is important in this context because, in contrast to Barthes, he was committed making the past active in the present. Benjamin was concerned to recapture the past from the 'victors' who normally define history. For him, nothing in the past had truly

disappeared forever; its traces could be rediscovered and put to use. It seems important, in these dark times, to emphasize this possibility that the image can bring past events to life for contemporary viewers; to stress its ability to testify, or to bear witness, for us.

Photography is often spoken of as intimately wrapped up with remembrance: Holmes's 'mirror with a memory' is a good example, while an advertisement for Kodak suggested scenes could be captured 'which would otherwise fade from memory and be lost'; one recent advertisement on the London Underground recommends that photographs stored on a computer should be printed on (the company's) permanent paper to avoid the risk of losing precious 'memories'. From the outset, photography was seen as a privileged vehicle for acts of remembrance. Photographic portraits were handed out to family, friends, and acquaintances; memorial pictures were taken of those who had recently died; and, then as now, people carried photographs of loved ones with them. A photographic likeness seems to have the effect of bridging distance and heightening the effects of memory, reminding us of those who are absent.

The photograph seems to testify that particular people existed or that things actually happened and to recall us to these moments. In this sense, Barthes's argument for consigning photographs to the past is counter-intuitive. Memory is, after all, a trace or impression of the past that takes place in the *present*. While his account may be no worse for shaking up some common-sense perceptions, it does seem that there is a case to consider here. In our amnesic culture, Barthes's refusal to allow the past into the present seems strangely complicit with society's current drive to forget.

Marcel Proust's idea of involuntary memory, elaborated in his great novel *Remembrance of Things Past*, may be helpful here. Proust aimed, and in this, at least, he was at one with the Symbolist movement of his time, to capture a past moment in all its fullness.

Proust contrasted the inadequacy of 'voluntary memory', in which we consciously try to recall the past, to 'involuntary memory', which floods through us as a response to some unexpected stimulus. Voluntary memory, he felt, was always frustrated in its goal, whereas the unwilled memory could be more successful in capturing a moment of past time. His classic example of involuntary memory records the way that the taste of a 'petite madeleine' (a small cake) dipped in tea called up, for his narrator/character Marcel, long-forgotten people and situations. Proust was fascinated with photographs, and they figure repeatedly in his writing. For him, photographs provide a key stimulus for involuntary memory, which, as the photographer Brassaï put it in his book on Proust and photography, 'can exert a power as if they were actual living persons'. The photograph of his grandmother, for instance, 'torments the narrator', while that of Albertine (Marcel's object of desire) 'provokes jealousy', and so on. Proust's sense of the photograph runs counter to Barthes's account of the experience of photographs as memorial. (If anything, Proust tended to collapse the distance between the photographic image and its model, as if the picture could restore the presence of the absent person.) Marcel notes of his grandmother: 'The great fact we must try to remember is not that photographs . . . seem to make us believe that she is still here, the great fact we must try to remember is the contrary: she no longer exists.'

If Proust seems over-invested in the restored presence that photographs conjure up, his sense of memory captures something significant about our experience of photographic images. Photographs provoke acts of memory recalling us to things, places, and people. They establish connections across time and space, inducing chains of association. What will be dredged up in memory's driftnet cannot be predicted in advance: an item of clothing or décor in a picture can spark connections and associations. This may be why discussions of family photographs rarely dwell on the images themselves. This absence of address to the images can seem like a lack of attention, in the face of the

pictures: it as if the banality of their form blocks concentration – a view captured by an old Monty Python sketch, which goes something like: '[t]his is me in front of the house; this is me at the side of the house, but you can still see part of the front of the house; this is me at the side of the house; this is me at the back of the house, but you can still see part of the side of the house'. We have all been there – oh no, not the holiday snaps! In fact, this seeming distraction is probably a characteristic of the particular memory effect generated by these pictures. Photographs act as prompts or provocations for stories and reminiscences. Acts of memorization spin off from these powerful points of association.

The classical site for this kind of storytelling as memory is the family album, which became commonplace during the 1860s, but is now as likely to exist as packets or envelopes held together by an elastic band, or a number of computer files. Family photography is a much larger topic than I have scope to address here, but it is instructive in a number of ways. Firstly, it seems that memory emerges when the image is used in a particular social network – in this case, a family gathering. Memory connects with the image or 'sparks' from it: 'Who is this? That's Aunt X. Sad story that one ' Secondly, these narratives are not unstructured. It is worth observing that while it is usually men who take family pictures (initially professional photographers and later, when camera technology became simpler and widely available, as amateurs), women typically act as the gatekeepers of family memory. Mothers and grandmothers take charge of the album; they arrange it, store it, and bring it out for display and discussion. And as Annette Kuhn suggests: 'Family photographs are quite often deployed – shown, talked about – in series: pictures get displayed one after another, their selection and ordering as meaningful as the pictures themselves.' Thirdly, what is omitted from this collection is as important to these structured memories as what is included. As Jo Spence – photographer and critical navigator of the medium's uses – pointed out, the

24. Jo Spence

events chosen for commemoration in the album are highly selective.

Spence argued that the family album memorialized high days and holidays, important rites of passage, but it left out funerals and divorces, illness and family feuds. Perhaps, even more importantly, the album presents a vision of the family as a sealed unit impervious to public events or social upheavals. The tight focus of the family album, encouraged by photographic manufacturers, falls on the cycles of family reproduction: weddings and ceremonies associated with greeting new children into the world, coming-of-age rituals, holidays and family gatherings, prized possessions, and so forth. Occasionally, a male relative may appear in military uniform, but public events rarely impinge directly on the experience of everyday life as it is depicted in the album. Even work is largely absent, though it may sometimes figure through an image of the work's party or outing. In this sense, the album embodies a particular ideology of the family as personalized space, organized around female experience.

Some recent commentators have used the category of 'memory work' to interrogate the operations of memory and its connection to photography. Memory work (the allusion is to Freud's interpretation of dreams, or 'dream work') does not assume that memories, or the related question of photographic remembrance, are direct reflections of the past. As Kuhn suggests: 'memory work undercuts assumptions about the transparency or the authenticity of what is remembered, treating it not as "truth" but as evidence of a particular sort: material for interpretation, to be interrogated, mined for its meanings and its possibilities'. Memory work revisits the past critically, examining the way memories are presented, and pays as much attention to what has gone unsaid as what is explicitly proclaimed. This enterprise, which is probably best seen as a critical form of autobiography, interrogates the life story as a *story*, and the emphasis is on the construction of the account, on fictionalization, omissions and occlusions. Spence's own interrogation of the photographic album and family memory in her writing, photographs, and photo-therapy sessions (in which she and others restaged the occasions and events occluded from the album) represents one important contribution to this project of memory work; Kuhn's interrogation of gender and class memories through photographs in her book *Family Secrets* is another. But it would be a mistake to confine this engagement with the family album to specialist re-interpreters of memory. Key events may be absent from the pictures collected in the album, but the discussion and storytelling that go on around it – the occasion of family memory – does, to some extent, raise and address these issues.

Whereas family photographs provoke memories shared by a handful of close friends or relatives, photographs can also tap into collective or 'popular' memories, recalling the viewer to events experienced by wider social groups. Family memory typically focuses on the rounds of everyday life, but collective memory speaks to those public events that have been experienced by large numbers of people. The contents of collective memory relate to

the world historical events that disrupt everyday life: wars, revolutions, invasions, occupation and liberation; economic upheavals; 'natural disasters' like earthquakes and floods; and so on. But this kind of memory can also include shared celebrations encompassing everything from national anniversaries to a sporting occasion. Photographic images play as significant a role in shaping public memory as they do in family memory. These images often allow us to make sense of an event and to fix a particular image of it. The photographs that take on this role often articulate some shared experience or need. Nevertheless, this does not mean that collective remembering is necessarily productive of social coherence. Photographs can call up very different perspectives on the past for the distinct groups involved in those events. For instance, war-time occupiers and those whose cities were occupied are unlikely to respond in the same fashion to a photograph of tanks on the streets. The memories elaborated on the basis of photographs are productive of social division and conflict just as easily as social coherence. Which photographs stick often depends on how they crystallize a particular view of events. Even some of the most iconic documentary pictures taken during wars or periods of economic depression are frequently dismissed as tendentious by one camp or another.

There is no doubt that memory is an active process, constructing the past in the present, selecting and reshaping it according to current preoccupations. Neither is it disputable that photographs sometimes displace memory or substitute for it. We know that many of the iconic images of the American Civil War, taken under the auspices of Mathew Brady, involved carefully rearranged corpses or assistants posed as dead troops; the equally iconic image of three American soldiers raising the flag on Iwo Jima was staged for the camera (one of the soldiers has expressed his unease at the use of this picture); Capa's death of a Republican soldier may (or may not) have been staged; while the memories of those who lived through the London Blitz often

seem like descriptions of the documentary images that appeared in *Picture Post* or scenes from the film *Fires Were Started*. Sometimes photographs are set up in order to deliberately mislead viewers; often they are posed, or rearranged, for ease of production or to increase the visual impact. Sometimes images are so powerful that they seem to replace events themselves in memory.

In fact, we usually witness the most important political and social events through images. In most instances, the historic events that shape our lives, and which constitute the stuff of memory, are not directly experienced by many individuals; nevertheless, we encounter these events via documentary pictures (and interviews with those who did witness them). It is one of the most revolutionary implications of photography that we do not need to have been present at a particular event to bear witness to it. Even if we have never visited a famine-stricken area or a war zone, we have some sense of the effects of these things on those that are forced to live through them. We should remember that these events are mediated to us by images – typically those subject to famine conditions are portrayed as passive victims – but at the same time, the paradoxes of index and trace, of then and now, which we have seen at work in photography, provide a foundation for memory and recognition. This suggests that an analytical division may be helpful: whereas memory entails association built on personal experience, testimony can involve events with which individuals have had no first-hand encounter but have access to through documentary records. Both memory and testimony involve forms of witnessing.

Chris Marker – who has been described as 'memory's greatest film-maker' – is an important point of reference here. Marker's films represent some of the most powerful reflections available on photography, memory, and history. Marker regularly bases his reflections on political memory on photographs or film clips. As Catherine Lupton notes, in the film *If I Had Four Camels*, he

employs as a device the 'familiar, even banal act of leafing through a collection of photographs in the company of friends, seizing on images that attract attention, and weaving anecdotes, interpretations and arguments around them'.

In an epigraph to Marker's film *The Last Bolshevik*, George Steiner observes 'it is not the past that dominates us, but images of the past'. Or, as Marker has his surrogate Sandor Krasna put it in *Sunless*: 'I remember that month of January in Tokyo, or rather I remember the images I filmed of that month of January in Tokyo. They have substituted themselves for my memory, they *are* my memory.' Marker's films are dense with references of this kind; with musings on images substituting for knowledge of events. There is clearly an important point here. But this does not mean that memory is blocked by photographs. Marker advocates a form of Proustian memory (interestingly, he observed in his CD-ROM project *Immemory* that the central female character in Hitchcock's *Vertigo*, a film that turns on memory and trauma, is called 'Madeline'). Marker's works are striking projects of memory work, labouring over the revolutionary turmoil of the 20th century, speculating on representation then and now, on memory and forgetting. His work remembers the present, from the position of a not yet realized future.

As I have suggested, it may help to distinguish between photographic memory and photographic witnessing or testimony. The terms, it should be said, are not stable or easily separable. Nevertheless, there is a significant point to be made about types of memory and an arbitrary division between overlapping categories will have to be made for ease of exposition. In a film like *Sunless*, many of the events contemplated by Krasna/Marker were not witnessed first hand. They come from the work of other photographers and film-makers. But Marker treats these representations as testimony of the episodes in question. He is prepared to work over these images, to question the manner in which they depict particular events, to raise what they leave

invisible, to point to moments of amnesia and so forth, while at the same time regarding the pictures and film as structured testimony. A photograph of mass graves, torture victims, or famine acts as evidence of things that some would wish covered up. In Barthes's sense, these pictures place us before these events, but (pace Barthes) in doing so they can challenge us to face these horrors, to remember them, and to act.

There is a public recognition that the saturation of mass media pictures of traumatic events may have the opposite effect: the sheer number of these pictures can generate a sense of dumb resignation and hopelessness ('the poor are always with us'). It is also plausible to argue that photographs of this type can encourage forgetting as attention is displaced from one image to the one that inevitably follows. In this sense, the idea that photographs place us before these events is only half of the story. The effect of these pictures relies, just as much, on our not being there when these horrific things occurred. The news image offers viewers a *safe* perspective on dangerous events, making them bearable. Nevertheless, while this distance might neutralize the depicted trauma, it can also provide a critical vantage point from which to examine and contemplate it (immersion in a dangerous situation doesn't offer much scope for reflection). Proust described photography as an 'encounter *extended*' or as a 'prolonged encounter'. This detached, contemplative vision can generate passivity and helplessness, but it can also provide the critical distance and moral indignation required for action. Which option is taken is not an inherent property of the picture, but of the public discourse mobilized around it; of how it is put to work. In this sense, the trace of light recorded in the photograph can attest to some harsh realities and put the viewer in a place where ethical or political choices are called for.

Afterword: Digital photography

In this book I have deliberately left the question of digital photography to one side and focused on chemical or analogue photography. But digital photography has been around for some time and there is now an extensive debate concerned with the impact of digital technology on traditional conceptions of the medium. Some commentators argue that the new technologies represent a continuation of the key themes and practices associated with chemical photography; others suggest that the introduction of digital photography constitutes a radical break with the past. For the latter, the ideas presented in this short introduction may appear as period arguments of little relevance in the contemporary world. Unquestionably, digital technology has had an enormous impact on photography, changing the ways that images are made, stored, circulated, and used. It has also become relatively ubiquitous: when these technologies first appeared they were ferociously expensive and confined to a handful of wealthy institutions and specialists; now digital cameras are often built into quite standard mobile phones. In what follows, I am just going to sketch some basic points.

Digital photography developed some 30 years ago as a requirement of space exploration. Essentially, technicians faced the problem of how to send images across vast distances: there is no point dispatching a probe to photograph Saturn's rings if it subsequently drifts off into deep space with the film remaining on board. A

system had to be found for recovering the images by transposing them into information capable of transmission via radio waves. This problem was solved by translating visual information into a binary computer code (ones and zeros): hence the term 'digital imaging'. In this process, the image we see is made up from a myriad of picture elements, or 'pixels', each of which contains particular information. A good way to envisage this technology is to imagine a grid superimposed over a conventional photograph. Each component of the grid, or pixel, holds information on luminosity and/or colour. In this way, an image can be generated either by translating a conventional photograph into digital information via a scanning device, or directly with a digital camera. In some respects, digital photographs are similar to television images: TV screens are also made up of lots of individual picture elements, which are activated through broadcast transmission. There is no permanent image on a television screen: the picture changes in response to impulses switching individual pixels on and off. To fix these images, they have to be recorded on film or magnetic tape.

So far, there is nothing particularly contentious in this account. However, in one fundamental aspect digital images differ radically from all previous photographic forms. Conventional photographs register intensities of light through the physical changes in chemicals (typically silver), but digital images result when light is electronically translated into a code. The consequence of this is that each individual pixel can subsequently be transformed by altering the code. Initially, doing this involved computer programmers entering complex algorithms into a computer, but now programs are readily available that allow changes in the image to be made through a series of simple commands. At the touch of a button (or a keystroke), a colour image will shift to sepia tone. More fundamentally, to give just a couple of examples, an edit facility allows images to be compiled, almost seamlessly, from multiple sources – a landscape from here, a person from there, another from somewhere else. A cloning tool (which enables users to copy a section of an image and repeat it) means that unwanted features

can be removed and replaced, leaving little evidence of the former presence. These changes leave virtually no trace in the final image.

One commentator has, rather graphically, suggested that this technology allows editors 'to reach into the guts of the image and manipulate it'. As we have seen, photographs have always been 'manipulable': the choices made by the photographer play a large part in determining what appears and how it appears, treatment with a brush or montaging elements allows existing images to be changed, but the new technologies make all this much easier. Stalinist censors had to go to a great deal of trouble to remove the likes of Leon Trotsky from photographs; this kind of intervention is now much more straightforward.

Two more factors need to be registered here. Firstly, digital images do not necessarily have a fixed, original form. It is possible to save these images, just as you save computer files, on some memory device, but this is not necessarily how they are used. A photograph can be emailed directly to an editor, or other client, who might rework it on a computer, before printing or circulating it. The image can appear in a range of different forms and it is not easy to establish its initial source. In contrast, chemical photography – in principle at least – allows us to check an image against the negative from which it was printed. Of course, this is not foolproof, but it does offer a way of detecting subsequent changes to an image. The absence of a negative can itself be suspicious. It is also possible to identify physical changes to the emulsion of the negative or print, but a pixel is just a pixel. It can be impossible to tell if a digital image has been altered. Secondly, computer-generated images that mimic the appearance of photographs are now created from scratch on a computer. In this way, it is possible to create 'photographs' of things that have no independent or prior existence. This technique is increasingly used in action and fantasy film-making. Generating images in this form still requires a great deal of specialist labour; some surfaces are more easily imitated than others – currently, computer-generated humans tend to look like mannequins. It is a

matter of some dispute whether existing shortcomings can be overcome with increased computing power.

The digitalization of photography has changed not only the means by which photographs are made, but also the way that they can be stored and circulated. Digital photographs are eminently suited to storage on computer memory devices, and it is now a relatively simple task to produce complex narratives in which pictures appear in sequence, often in dissolves, and to provide accompanying sound tracks or to overlay type. These edits can be stored and viewed on computers or displayed via data projectors; alternatively, they can be posted in cyberspace. Techniques like this mean that a large number of people now have access to relatively professional forms of display. The *New York Times* recently observed that US soldiers had edited photographs and music to create memorial presentations for comrades killed in Iraq. (Interestingly, officers insisted on ensuring they featured nothing contentious.) The home computer is increasingly replacing the album as the preferred storage site for family photographs; these pictures can be simply stored this way or edited into more complex family memories. The web means that digital images can be publicly circulated without significant recourse. The internet is now awash with sites containing photographic presentations made by individuals or small groups. This relative ease of distribution makes official control of images very difficult.

With the exception of computer-generated pictures, none of these distinctions between digital and chemical photography are clear-cut. More than some people want to admit, chemical images conform to most of the features singled out as properties of the digital image – photographs have never been direct copies of their pro-filmic event. Indeed, it may be that digital pictures serve, retrospectively, to emphasize just how conventional all photographic images actually are. Nevertheless, the advent of digital imaging has placed a question mark over photography.

Reactions to these changes tend to come in both utopian and dystopian forms. Techno-Utopians view digital photographs as a component of the 'information revolution', which they see as democratically empowering. The argument here is that this technology now makes access to information (in this case images) easy for everyone, while enabling people to use this information in ways previously unimaginable. At its wilder edges, this argument shades into science fiction, suggesting that we are all about to become cyborgs with cameras and memory chips implanted in our eyes or brains – literally, creating a photographic memory. In more restrained mood, the champions of digital technology point out that anyone can now produce and distribute pictures freely on the web. It is worth noting, though, that large sections of the world's population don't have telephones or even electricity, let alone the ability to generate and circulate images. Access to technology is as unequal as access to any other kind of resource.

Techno-Utopians tend to see information and communication as inherently positive and ignore the social relations of technology; they pass over inequalities of power and wealth, and they assume the processes involved are neutral. However, huge corporations and wealthy individuals have the resources and political influence to impose their agendas. Currently, private corporations are lobbying hard to turn the internet into a profitable and restricted business. In contrast to the utopian vision, doom and gloom merchants view the effects of the new image technologies with near-apocalyptic dismay. Digital images, they argue, entail the end of photographic 'truth'; they subject us all to endlessly circulating falsehood and fantasy. We are told that the world is now so awash with images that nothing can really be absorbed or tested. In these conditions, Techno-Dystopians argue, everything is spectacularized; attention deficit is generalized; military vision normalized.

Yet, images now circulating on the web clearly play a role in challenging the very features characterized as essential to this new technical universe. While digital encoding makes certain things

possible, and rules others out, both sides of the argument tend to neglect the fact that what we actually do with this technology is not fixed at the outset. The uses of technology always exceed what was initially envisaged for it; what a technology becomes is usually the result of conflicting interests attempting to cast it in their own image. Some people have a greater ability to determine the outcome of this struggle for definition than others, but they do not have it all their own way and the final form is not pre-given. The new technology could enhance the democratic circulation of information, or be channelled into restricted commercial forms; it could allow people to enter directly into the production of meaning, or position them as relatively passive recipients of representations authored by a small coterie of media professionals. At the moment, we are in the middle of a maelstrom when all of these things seem to be taking place simultaneously.

This is not to say that the new photographic techniques are not having an immediate impact. For instance, documentary photography is facing a mounting crisis. The emergence of digital technology, which allows for the manipulation of images without leaving any evidence of the intervention, poses a fundamental challenge to traditional notions of documentary evidence. In one sense, as I have argued, this belief in unmediated access to reality is misguided, but, nevertheless, this challenge has called into question the self-image of the documentary photographer. In part, the crisis is of a longstanding nature: we are long past the time when photographs possessed much novelty value; now documentary photographers' wares take their place alongside flashy commodities clamouring for attention; the decline in picture magazines has also removed a key base of support. However, technological changes in the media are undoubtedly having a profound impact. It has been estimated that one-third of news photographs now come from 'video grabs' (single images extracted from video). This is often the preferred image source for many editors of newspapers and magazines. The media's preference for digitally produced photographs that can be quickly emailed to the publisher often

strips photographers of an archive of negatives (a key economic recourse). In addition, images recorded by bystanders with cheap digital technology can sometimes substitute for professional images. Many documentary photographers now find it difficult to obtain assignments or place their images.

At the same time, though, the combination of digital photography and the internet is opening up new possibilities for the use of images. Things may change in this respect, but at the moment the internet allows access to all manner of images and makes it relatively easy for groups or individuals to circulate photographs in innovative and critical ways, which would previously have been unavailable or difficult to view. While it is clogged with amateur porn sites, neo-Nazi propaganda, and billions of sales pitches, the web is also an arena for critical projects, artists' interventions, and 'unofficial' witness pictures. For those who are interested, photographs can be accessed form all parts of the world that that have not been filtered for conformity with the approved perspectives of governments or business concerns. For every tourist brochure there is now an activist site decrying the impact of economic development on the local environment and indigenous people. While the established news media appear increasingly locked into permitted 'safe zones' around the world, alternative sources of information are all readily available to those who have a computer and a phone line. At a time when the official media seems increasingly part of the consensus on the supposed benefits of privatization and free capital flows (but not free movement of people), the internet has come to play a vital role raising alternative perspectives. Indeed, on some crucial issues the internet is almost the only way, for most people, to find out what is going on in the world: ordinary witnesses post pictures of the insurgency in Iraq or the situation of the poor inhabitants left to cope for themselves after the hurricane devastated New Orleans; alternative media outfits circulate their findings; and campaign groups elicit support and mobilise supporters through the web. This is not to say that national states do not have their ways of policing what appears on

the internet – they do, but it has made it much more difficult to maintain the virtual monopoly of information they have previously enjoyed, and opponents of the official vision are becoming increasingly savvy in using this alternative network of distribution. In this sense, digital photography probably provides the best opportunity for the circulation of serious photographic work since the demise of the picture magazines.

In conclusion, it is worth, briefly, considering two frequently discussed questions in relation to digital imaging. Firstly, to what extent are digital images photographs? Secondly, what are the implications of this technology for photographic evidence, or 'truth'? No less than chemical photography, digital photographs are predicated on an indexical relation of image and referent in so far as light entering a camera is electronically processed to generate a code. But, as pixels are progressively transformed, this relation is weakened. It is difficult to avoid getting caught up in scholastic disputes here: for instance, if an image of a motorcar is changed on a computer into a picture of a bicycle, at what point does it cease to be a photograph? Any point at which we demarcate this shift from quantity to quality is inevitably arbitrary.

For what it is worth, I think that it is possible to point to two features that characterize photographs – sometimes they overlap, but not in every instance. Firstly, photographs result from the trace left by light (or other forms of radiation) on a receptive substance. Photographs are a kind of sculpting with light. Even manipulated images – montaged, or reworked in other ways – are still based on traces of some pro-filmic event. In this sense, computer-generated images may, to a greater or lesser extent, look like photographs, but they depart from them in significant ways. Secondly, and perhaps more importantly, photographs are rooted in a particular architecture involving a lens and a dark box. It is possible, with a computer, to produce images that do not adhere to the spatial characteristics of this kind of image, but, in the process, they seem to me to depart from a fundamental property of photography. In so

far as digital images reproduce the characteristic features of an image made with a lens and a film plane (and most do), they remain photographic.

As I suggested, some have seen the advent of digital photography as representing a crisis in photography's ability to truthfully represent reality; in turn, this has been taken as a symptom for a wider crisis in social knowledge. As a way of allaying this worry about altered photographs, some commentators have suggested that newspapers ought to identify images that have been 'manipulated'; alternatively that a 'kite mark' might be used to affirm an image had not been digitally enhanced. Both suggestions seem a little fanciful (though the potential threat posed by digital transformation to the state's use of photographic evidence may necessitate some such system); besides which, arguments of this type tend to present the chemical photograph as inherently objective. As I argued in Chapter 5, photographic 'evidence' is far from being a straightforward matter; the question of 'truth' or 'reality' in photographs is even more problematic. Part of the problem with this view is that it conflates knowledge with the documentary mode. The documentary tradition has real strengths (I previously characterized these as an anti-subjective turn outwards towards the world), and the photographic trace may register evidence in particular instances, but neither should be taken as inherently truthful or as the solely realistic form of photography.

Seventy-five years ago, the German Marxist Bertolt Brecht wrote that a documentary image of a munitions factory didn't reveal much about the actual conditions of production inside its walls. We would learn more, Brecht thought, from 'something artificial, invented', or 'constructed'. Brecht's incredibly perceptive point suggests that mere fidelity to appearance does not necessarily help in understanding complex modern reality; in fact, a montage construction may show us more than a picture of this kind. The question of knowledge – of what we can learn from photographs – doesn't turn on the kind of objective conception often advanced; it

rather hinges on the information revealed. Digitally manipulated images can be used to mislead (as can chemical images), but this kind of intervention can just as easily allow us to see and understand more.

As the philosopher of science Ian Hacking has observed when looking through a scanning microscope, 'digitalization is marvellous for censoring noise [interference] and even reconstituting lost information'. He suggests that 'in the study of crystal structure, one good way to get rid of noise is to cut up a micrograph in a systematic way, paste it back together, and rephotograph it for interference contrast. Thus we do not in general see through a microscope; we see with one.' Hacking's point is that digital enhancement or manipulation does not necessarily entail a nightmarish loss of reality – it can help us to perceive things more clearly. The photograph is an aid to vision and what matters is what it can be used to see, not its supposed status as a literal copy, and certainly not its adherence to one particular visual tradition. The fundamental question at stake in these debates is not simply lodged in a technology; it is fundamentally an issue of social relations and of the ways in which the apparatus is actually employed. Perhaps, stripped of this simple version of realism, photography might emerge with a stronger, more sustainable conception of representation and evidence.

What is almost certain is that chemical photography will increasingly be restricted to a handful of craft practitioners, rather like etching or gum brichromate have been. An era has come to an end, and we are now quite probably on the verge of something new. It doesn't really matter if this is photography or not. However, the new may turn out to bear more than a close relation to what has gone on before. Much of what people actually do at the moment with digital technology is rather banal – they make the sky bluer, remove an obtrusive thumb, restore an old family picture, or add butterfly wings to a bride. Artists and experimentalists tend to make wonky pictures or fabricate wacky creatures like nothing on earth.

Usually this isn't very compelling. The more interesting usages of the medium so far have built on photographic space and used the technology to produce a heightened, disturbing realism.

Further reading

General

Classic histories of photography include:

Helmut and Alison Gernsheim, *The History of Photography: from the Camera Obscura to the Beginning of the Modern Era*, London: Thames & Hudson, 1969

Lucia Moholy, *A Hundred Years of Photography*, London: Penguin, 1939

Beaumont Newhall, *The History of Photography* (5th edition) New York: Museum of Modern Art, 1982

These works have largely been replaced by 3 large and copiously illustrated books; each has its strengths and weaknesses. The shift in titles from the earlier works is revealing:

Michel Frizot ed., *A New History of Photography*, Cologne: Könemann, 1994

Jean-Claude Lamagny & André Rouillé eds, *A History of Photography*, Cambridge: Cambridge University Press, 1987

Mary Warner Marion, *Photography: A Cultural History*, London: Laurnce King, 2002

The first two are slanted towards French material: Frizot includes a good bibliography; Lamagny & Rouillé has an excellent chronology; and Marion has a good time-line of photographs and photographic publications.

For an early critical account see:

Gisèle Freund, *Photography and Society*, London: Gordon Fraser, 1980. (This book was based on, what is said to be, the first PhD on photography, which Freund presented at the Sorbonne in 1936)

See also:

Val Williams, *The Other Observers, Women Photographers, 1900 to the Present*, London: Virago, 1991
Naomi Rosenblum, *A History of Women Photographers*, New York: Abbeville Press, 1994

Anthologies of writing (including important texts by photographers) include:

Vicki Goldberg ed., *Photography in Print*, Albuquerque: University of New Mexico, 1981
Liz Heron & Val Williams eds, *Illuminations: Women Writing on Photography from the 1850s to the Present*, Durham, N.C.: Duke University Press, 1996
Paul Hill & Thomas Cooper eds, *Dialogue with Photography*, New York: Farrar, Straus & Giroux, 1979
Nathan Lyons ed., *Photographers on Photography: A Critical Anthology*, Englewood Cliffs, N.J.: Prentice Hall, 1966
David Mellor ed., *Germany: The New Photography 1927-33*, London: Arts Council of Great Britain, 1979
Beaumont Newhall ed., *Photography: Essays & Images*, London: Secker & Warburg, 1980
Reninah R. Petruck ed., *The Camera Viewed: Writings on Twentieth-Century Photography (2 Vols.)*, New York: E.P. Dutton, 1979
Christopher Phillips ed., *Photography in the Modern Era: European Documents and Critical Writings, 1913-1940*, New York: Metropolitan Museum of Art/Aperture, 1989
André Rouillé, *La Photographie en France. Textes & Controverses: une Anthologie 1816-1871*, Macula, 1989

Recent critical anthologies include:

Richard Bolton ed., *The Contest of Meaning: Critical Histories of Photography*, Cambridge Mass.: MIT, 1989

Jessica Evans ed., *The Camerawork Essays*, London: Rivers Oram Press, 1997

Liz Wells ed., *The Photography Reader*, London: Routledge, 2003

Probably the best current introduction is:

Liz Wells ed., *Photography: a Critical Introduction* (3rd edition), London: Routledge, 1996

But still of value is:

Susan Sontag, *On Photography*, London: Penguin, 1979

Listed below by chapter are works referred to in the text or particularly influential accounts for each subject. I have not cited individual books by photographers.

Preface

John Tagg, *The Burden of Representation: Essays on Photographies and Histories*, Houndmills: Macmillan, 1988

Chapter 1 Forgetting photography

The citation from Olivier Richon is from 'Thinking Things' in David Green ed., *Where is the Photograph?*, Brighton: Photoforum, 2003, pp.71–9

Dr Hugh Diamond, 'Report of Jurors', *The Photographic Journal*, August 15, 1863, pp.339–46

William Bornefeld, *Time and Light*, Clarkston, G.A.: White Wolf, 1996

James Mudd, 'A Photographer's Dream', *The Photographic News*, May 5, 1865, pp.212–214; & May 12, 1865, pp.222–223

Siegfried Kracaeur, *The Salaried Masses: Duty and Distraction in Weimar Germany*, London: Verso, 1998

John Szarkowski, *William Eggleston's Guide*, New York: Museum of
Modern Art, 1976

For Benjamin's important contributions see:

Walter Benjamin, 'New Things About Plants' (1928), David Mellor ed.,
Germany: The New Photography 1927–33, London: Arts Council of
Great Britain, 1978, pp.20–1
Walter Benjamin, 'A Small History of Photography' (1931), *One Way
Street and Other Writings*, London: Verso, 1985, pp.225–239
Walter Benjamin, 'The Work of Art in the Age of Mechanical
Production' (1936), *Illuminations*, London: Fontana,
1970, pp.219–253

Chapter 2 Documents

For Academic art theory see:

Sir Joshua Reynolds, *Discourses on Art*, New Haven: Yale University
Press, 1975
E.G. Holt ed., *A Documentary History of Art, II: Michelangelo and the
Mannerists, the Baroque and the Eighteenth Century*, New York:
Doubleday Anchor Books, 1958
Charles Harrison, Paul Wood and Jason Gaiger, *Art in Theory
1648–1815: An Anthology of Changing Ideas*, Oxford: Blackwell,
2000

For an overview:

Gill Perry and Colin Cunningham eds, *Academies, Museums and
Canons of Art*, New Haven: Yale University Press, 1999

For photography and Academic ideas:

Richard Shiff, 'Phototropism (Figuring the Proper)', *Studies in the
History of Art*, Volume 20, 1989, pp.161–179
Joel Snyder, 'Res Ipsa Loquiter', Lorranie Daston ed., *Things that Talk:
Object Lessons from Science and Art*, New York: Zone Books, 2004,
pp.195–231

Steve Edwards, *The Making of English Photography, Allegories*,
 Pennsylvania: Penn State University Press, 2006

In addition to her essays in Frizot and Lemagny & Rouillé, for Nesbit's
important work see:

*Molly Nesbit, *Atget's Seven Albums*, Yale University Press, 1992

On objectivity:

Peter Dear, 'From Truth to Disinterestedness in the Seventeenth
 Century', *Social Studies of Science*, Vol. 22, No. 4, November 1992,
 pp.597–618
Lorraine Daston, 'Objectivity and the Escape from Perspective', *Social
 Studies of Science*, Vol. 22, No. 4, November 1992, pp.619–631
Lorraine Daston and Peter Galison, 'The Image of Objectivity',
 Representations, No. 40, Fall 1992, pp.81–128
Steve Shapin, *The Social History of Truth: Civility and Science in
 Seventeenth-Century England*, Chicago: The University of Chicago
 Press, 1994

On photography and the 'archives of subjection':

*John Tagg, *The Burden of Representation: Essays on Photographies
 and Histories*, Houndmills: Macmillan, 1988
*Allan Sekula, 'The Body and the Archive', *October*, No. 39, 1986,
 pp.3–64

See also:

*Elizabeth Edwards ed., *Photography and Anthropology 1860-1920*,
 New Haven, Yale University Press, 1992
*David Green, 'Classified Subjects. Photography and Anthropology: The
 Technology of Power, *Ten. 8*, No. 19, 1984, pp. 30–37
*David Green, 'A Map of Depravity', *Ten. 8*, No. 18, 1985, pp.37–43
*David Green, 'Veins of Resemblance: Photography and Eugenics',
 Patricia Holland *et al*. eds, *Photography/Politics: Two*, London:
 Comedia/Photography Workshop, 1986, pp.9–21

Malek Alloulu, *The Colonial Harem*, Manchester: Manchester
University Press, 1987

*Roberta McGrath, 'Medical Police', *Ten. 8*, No. 14, 1984, pp.13–18

Much of this work draws its inspiration from the historian of ideas
Michel Foucault. For an example see:

*Michel Foucault, *Discipline and Punish: The Birth of The Prison*,
Harmondsworth: Penguin, 1977

On 'documentary':

*John Grierson, *Grierson on Documentary*, London: Faber & Faber,
1966

*William Stott, *Documentary Expression and Thirties America*, Oxford:
Oxford University Press, 1973

*Walker Evans at Work: 745 Photographs together with Documents
selected from letters, Memoranda, Interviews, Notes*, New York:
Harper & Row, 1982

*Stuart Hall, 'The Social Eye of Picture Post', *Working Papers in
Cultural Studies*, 2, Spring, 1972, pp.71–120

*Martha Rosler, 'In, Around, and Afterthoughts (On Documentary
Photography)', *Martha Rosler, 3 Works*, Halifax, Nova Scotia:
The Press of Nova Scotia College of Art and Design, 1981, pp.59–86

*Allan Sekula, *Photography Against the Grain: Essays and Photo
Works, 1973–1983*, Halifax, Nova Scotia: The Press of Nova Scotia
College of Art and Design, 1984

*Maren Stange, *Symbols of Ideal Life: Social Documentary
Photography in America 1890–1950*, Cambridge: Cambridge
University Press, 1989

*Abigail Solomon-Godeau, *Photography at the Dock: Essays on
Photographic History, Institutions and Practices*, Minneapolis:
University of Minnesota Press, 1991

*Paula Rabinowitz, *They Must be Represented: the Politics of
Documentary*, London: Verso, 1994

*Julien Stallabrass, 'Sebastião Salgado and Fine Art Photojournalism',
New Left Review, No. 223, May/June, 1997, pp.131–160

Other works cited:

*William Henry Fox Talbot, 'Some Account of the Art of Photogenic Drawing . . . ', Newhall ed., pp.23–32

*Tom Harrison, 'Introduction to Poles Apart', cited in Tom Jeffrey, *Mass Observation – a Short History*, Centre for Contemporary Cultural Studies, Occasional Stencilled Paper, No. 55, pp.141–8

*Nicolas Monti, *Africa Then: Photographs 1840–1918*, London: Thames & Hudson, 1987

*Brassaï, *Proust: in the Power of Photography*, Chicago: The University of Chicago Press, 2001

John Roberts, *The Art of Interruption: Realism, Photography and the Everyday*, Manchester: Manchester University Press, 1998

Chapter 3 Pictures

Nineteenth-century photography and Pictorialism:

Henry Peach Robinson, *Pictorial Effect in Photography*, London: Piper and Carter, 1869

Grace Seiberling (with Carolyn Bloore), *Amateurs, Photography and the Mid Victorian Imagination*, Chicago: The University of Chicago Press, 1986

Carol Armstrong, *Scenes in a Library: Reading the Photograph in the Book, 1843–1875*, Cambridge, Mass.: MIT, 1998

Steve Edwards, *The Making of English Photography, Allegories*, Pennsylvania: Penn State University Press, 2006

Peter Bunnell ed., *A Photographic Vision: Pictorial Photography, 1889–1923*, Salt Lake City: Peregrine Smith, Inc., 1980

Katherine Hoffman, *Stieglitz: A Beginning Light*, New Haven: Yale University Press, 2004

Avant-garde:

Peter Bürger, *Theory of the Avant-Garde*, Manchester University Press, 1984

Andreas Haus, *Moholy-Nagy: Photographs and Photograms*, London: Thames and Hudson, 1980

Christopher Phillips, 'Resurrecting Vision: European Photography Between the World Wars', Maria Morris Hambourg and Christopher Phillips, New York: *The New Vision: Photography Between The World Wars*, The Metropolitan Museum of Art, 1994, pp.65–108

Mathew Teitelbaum ed., *Montage and Modern Life, 1919–42*, Cambridge, Mass.:MIT, 1992

Margarita Tupitsyn, *The Soviet Photograph, 1924–1937*, New Haven: Yale University Press, 1996

On 'street photography':

Henri Cartier-Bresson, *The Decisive Moment*, New York: Simon & Schuster, 1952

Max Kozloff, *New York: Capital of Photography*, New York: The Jewish Museum, New York/ Yale University Press, 2002

Colin Westerbeck and Joel Meyorowitz, *Bystander: A History of Street Photography*, London: Thames & Hudson, 1994

Bob Bowman ed., *Open City: Street Photography Since 1950*, Oxford: Museum of Modern Art, 2001

Szarkowski and 'formalism':

John Szarkowski, *The Photographer's Eye*, London: Secker & Warburg, 1966.

John Szarkowski, *William Eggleston's Guide*, New York: Museum of Modern Art, 1976

John Szarkowski, *From the Picture Press*, New York: Museum of Modern Art, 1973

John Szarkowski, *Looking at Photographs, 100 Pictures from the Collection of The Museum of Modern Art*, New York: Museum of Modern Art, 1973

Allan Sekula, 'Dismantling Modernism, Reinventing Documentary (Notes on the Politics of Representation)', (1976/78), *Photography Against the Grain: Essays and Photo Works, 1973–1983*, NSCAD, 1984, pp59–60

Christopher Phillips, 'The Judgement Seat of Photography', Richard

Bolton ed., *The Contest of Meaning: Critical Histories of Photography*, MIT, 1989, pp.14–47

Steve Edwards, 'Vernacular Modernism', Paul Wood ed., *Varieties of Modernism*, New Haven: Yale University Press, 2004, pp.241–68

Photography after Conceptual art:

John Coplans, 'Concerning "Various Small Fires": Edward Ruscha Discusses His Perplexing Publications.' *Artforum*, Vol. 3 No. 5, 1965, pp.24–25

Douglas Crimp, 'The Museum's Old/The Library's New Subject', *Parachute*, No. 22, 1981, pp.32–7

Laura Mulvey, 'A Phantasmagoria of the Female Body: The Work of Cindy Sherman', *New Left Review*, No. 188, July/August 1991, pp.136–50

Judith Williamson, 'Images of "Woman" – the Photographs of Cindy Sherman', *Screen*, Vol. 24, No.6, Nov/Dec 1983, pp.102–16

Jeff Wall, '"Marks of Indifference": Aspects of Photography In, Or As, Conceptual Art', Ann Goldstein and Anne Rorimer eds, *Reconsidering the Object of Art: 1965–1975*, Museum of Contemporary Art, Los Angeles/MIT, 1995, pp.247–67

John Roberts ed., *The Impossible Document: Photography and Conceptual Art in Britain 1966–1976*, London: Camerawords, 1997

Debra Risberg, 'Imaginary Economies: An Interview With Allan Sekula', Allan Sekula, *Dismal Science: Photo Works 1972–1996*, University Galleries of Illinois State University, 1999, pp.236–51

Steve Edwards, 'Photography Out of Conceptual Art', Gill Perry & Paul Wood eds, *Themes in Contemporary Art*, New Haven: Yale University Press, 2004, pp.137–80

David Campany ed., *Art and Photography*, London: Phaidon, 2003

Chapter 4 What is a photograph?

For the theories of the photograph discussed in this chapter see:

Andre Bazin, 'The Ontology of the Photographic Image', *What is*

Cinema? (Vol. 1), Berkeley, Calif.: University of California, 1967, pp.9–16

Rudolf Arnheim, 'On the Nature of Photography', *Critical Inquiry*, Vol. 1, No. 1, September, 1974, pp.149–61

Charles Sanders Pierce, 'Logic as Semiotic: The Theory of Signs', Justus Buchler ed., *Philosophical Writings of Pierce*, Dover, 1955, pp.98–119

Thierry de Duve, 'Time, Exposure and Snapshot: The Photograph as Paradox', *October*, No. 5, Summer, 1978, pp.113–25

Joel Snyder, 'Picturing Vision', *Critical Inquiry*, 6, Spring, 1980, pp.499–526

Joel Snyder, 'Enabling Confusion', *History of Photography*, Vol.26, No. 2, Summer 2002, pp.154–60

Peter Osborne, 'Sign and Image', *Philosophy in Cultural Theory*, London: Routledge, 2000, pp.20–52

Films:

Proof. 1991, Dr. Jocelyn Moorehouse

Chapter 5 The apparatus and its image

Perception and perspective:

Leon Battista Alberti, *On Painting* (1435–6), New Haven: Yale University Press, 1966

J.P. Richter & I.A. Richter eds, *The Literary Works of Leonardo da Vinci*, London: Phaidon, 1970

Henri Pirenne, *Optics, Painting & Photography*, Cambridge: Cambridge University Press, 1970

Erwin Panofsky, *Perspective as Symbolic Form*, New York, Zone Books, 1991

Joel Snyder & Neil Walsch Allen, 'Photography, Vision and Representation, *Critical Inquiry*, 2, Autumn, 1975, pp.143–169

Joel Snyder, 'Picturing Vision', *Critical Inquiry*, 6, Spring, 1980, pp.499–526

Hubert Damisch, *The Origin of Perspective*, Cambridge, Mass.: MIT, 1994

Jacques Aumont, *The Image*, London: British Film Institute, 1997

Reality effect

Roland Barthes, 'The Reality Effect', *The Rustle of Language*, Oxford: Basil Blackwell, 1986, pp.141–8
Jean-Pierre Oudart, 'L'Effet de Réel', *Cahiers du Cinema*, No. 28, 1971, pp.19–28
Philip Rosen ed., *Narrative, Apparatus, Ideology: A Film Theory Reader*, New York: Columbia University Press, 1986

See also

Guy Debord, *The Society of the Spectacle*, New York: Zone Books, 1994

Narrative:

Roland Barthes, 'The Rhetoric of the Image', *Image-Music-Text*, London: Fontana Press, 1977, pp.32–51
Stuart Hall, 'The Determinations of News Photographs', *Working Papers in Cultural Studies*, 3, Autumn, 1972, pp.53–87
John Szarkowski, *From the Picture Press*, New York: Museum of Modern Art, 1973
W.G. Sebald, *Austerlitz*, London: Hamish Hamilton, 2001

Other works:

Oliver Wendell Holmes, *The Stereoscope and the Stereograph*, Newhall ed., pp.53–61
W.J.T. Mitchell, *Iconology: Image, Text, Ideology*, Chicago: University of Chicago Press, 1986
Tessa Morris-Suzuki, *The Past Within Us: Media, Memory, History*, London: Verso, 2005

Chapter 6 Fantasy and remembrance

Hollis Frampton, 'Digressions on the Photographic Agony', *Circles of Confusion: Film, Photography, Video. Texts 1968–1980*, Rochester, N.Y.: Visual Studies Workshop, 1983, pp.177–191

The literature on photography and commodity culture is now extensive but see:

Judith Williamson, *Decoding Advertisements: Ideology and Meaning in Advertising*, London: Marion Boyars, 1978 (The classic of the genre)

and for an overview:

Anandi Ramamurthy, 'Spectacles and illusions: Photography and Commodity Culture', Liz Wells ed., *Photography: a Critical Introduction*

Photography

For commodity culture and its critique:

Karl Marx, *Capital* Vol. 1, London: Lawrence and Wishart, 1954
Guy Debord, *The Society of the Spectacle*, New York: Zone Books, 1994
W.F. Haug, *Critique of Commodity Aesthetics: Appearance, Sexuality and Advertising in Capitalist Society*, Cambridge: Polity Press, 1986

On photography, death and remembrance:

Geoffrey Batchen, *Forget Me Not: Photography & Remembrance*, New York: Princeton Architectural Press, 2004

For Barthes on time and the image:

Roland Barthes, 'Rhetoric of the Image', *Image-Music-Text*, London: Fontana, 1977
Roland Barthes, *Camera Lucida: Reflections on Photography*, Hill & Wang, 1981
Peter Osborne, 'Sign and Image', *Philosophy in Cultural Theory*, London: Routledge, 2000, pp.20–52

For Proust see:

Marcel Proust, *Remembrance of Things Past*, 3 vols., Penguin, 1983

Commentaries on Proust and photography are to be found in:

Brassaï, *Proust: in the Power of Photography*, Chicago: The University of Chicago Press, 2001
Mieke Bal, *The Mottled Screen: Reading Proust Visually*, Stanford, Calif.: Stanford University Press, 1997

Family photography:

Jo Spence, *Putting Myself in the Picture: a Political, Personal and Photographic Autobiography*, Camden Press, 1986
Jo Spence and Patricia Holland eds, *Family Snaps: The Meaning of Domestic Photography*, London: Virago, 1991
Annette Kuhn, *Family Secrets: Acts of Memory and Imagination*, London: Verso (2nd Edition), 2002

Other works cited:

[Sir David Brewster], 'Photogenic Drawing, or Drawing by the Agency of Light', *The Edinburgh Review*, Volume LXXXVI, No. CLIV, 1843, pp.309–344
Jeff Wall, '"Marks of Indifference": Aspects of Photography In, Or As, Conceptual Art', Ann Goldstein and Anne Rorimer eds, *Reconsidering the Object of Art: 1965–1975*, Museum of Contemporary Art, Los Angeles/MIT, 1995, pp.247–67
Debra Risberg, 'Imaginary Economies: An Interview With Allan Sekula', Allan Sekula, *Dismal Science: Photo Works 1972–1996*, University Galleries of Illinois State University, 1999, pp.236–51
Yves Gevart ed., *A props du CD-ROM* Immemory *de Chris Marker*, Paris: Centre Georges Pompidou, 1997
Catherine Lupton, *Chris Marker: Memories of the Future*, London: Reaktion Books, 2005

Afterword: Digital images

Martin Lister ed., *The Photographic Image in Digital Culture*, London: Routledge, 1995

Martin Lister *et al.*, *New Media: a Critical Introduction*, London: Routledge, 2003

Fred Ritchin, 'Photojournalism in the Age of Computers', Carol Squiers ed., *The Critical Image: Essays on Contemporary Photography*, London: Lawrence & Wishart, 1990, pp.28–37

John Roberts, 'Digital Image and the Critique of Realism', *The Art of Interruption, Realism, Photography and the Everyday*, Manchester: Manchester University Press, 1998, pp.216–228

Martha Rosler, 'Image Simulations, Computer Manipulations: Some Considerations', *Decoys and Disruptions: Selected Writings, 1975-2001*, Cambridge, Mass.: MIT, 2004, pp.259–317

Other works referred to:

Bertolt Brecht, *On Film and Radio*, London: Metheun, 2000

Ian Hacking, *Representing and Intervening: Introductory Topics in the Philosophy of Science*, Cambridge: Cambridge University of Press

Index